W9-AZZ-393

my so-called digital life

2,000 TEENAGERS, 300 CAMERAS, AND 30 DAYS TO DOCUMENT THEIR WORLD

CREATED BY BOB PLETKA

Co-Creators: Ray Chavez, Dennis Jose, Shahnaz Lotfipour, Marty Silva, Christina Soderblum, and Brenda Williams

SANTA

MONICA

PRESS

Copyright ©2005 by Covina-Valley Unified School District

All rights reserved. This book may not be reproduced in whole or in part or in any form or format without written permission of the publisher.

SANTA
MONICA
PRESS

Published by:
Santa Monica Press LLC
P.O. Box 1076
Santa Monica, CA 90406-1076
1-800-784-9553
www.santamonicapress.com
books@santamonicapress.com

Printed in China

Santa Monica Press books are available at special quantity discounts when purchased in bulk by corporations, organizations, or groups. Please call our Special Sales department at 1-800-784-9553.

Library of Congress Cataloging-in-Publication Data

Pletka, Bob.
 My so-called digital life: 2,000 teenagers, 300 cameras, and 30 days to document their world / by Bob Pletka.
 p. cm.
 ISBN 1-59580-005-0
 1. High school students--California--Social life and customs--Pictorial works. 2. Middle school students--California--Social life and customs--Pictorial works. 3. Teenagers--California--Social life and customs--Pictorial works. 4. High school students--California--Social conditions--Pictorial works. 5. Middle school students--California--Social conditions--Pictorial works. 6. Teenagers--California--Social conditions--Pictorial works. 7. School environment--California--Pictorial works. 8. California--Social life and customs--Pictorial works. 9. California--Social conditions--Pictorial works. 10. Technology--Social aspects--California. I. Title.
 LA229.P55 2005
 779'.9305235'09794--dc22
 2005009678

Cover design and production by Future Studio
Cover photo by Adrian Arellano
Interior design and production by Dennis Jose and the students of Northview High School, Covina-Valley Unified School District (Cheryl Alegria, Josue Avalos, Adam Barrera, Samantha Gayton, Tessa Jimenez, Kyle Lowry, Monique Manzo-Flores, Cinthya Martinez, Guisell Rodriguez Rodriguez, Steven Salinas, Jennifer Snyder, and Allen Villanueva) with color assistance from Shana Jackson.

my so-called digital life

introduction

Throughout the generations, there has been a desire by parents to know what their children are learning in school. I remember being asked as a child what I learned today in school, and I have continued this questioning with my own children. I ask my daughter every evening what she learned in school that day. The response she gives is often quite predictable. "Nothing," she says. That response has always left me a bit stymied since she spends six hours a day in a place devoted to learning. I do examine her grades, test scores and even her NPR ranking from her standardized exams, all of which seem to indicate that she has learned something. However, what I want to know can't be adequately determined simply by examining her test scores.

A teenage boy, Fernando Perez, wrote "*En Los Ojos* (in her eyes) is the hope of her family." With that caption he encapsulated the reason I ask my daughter the aforementioned question every evening. For my wife and I, our daughter and our young son are our hope. We entrust our kids to a community of educators that we believe will inspire them to passionately pursue answers to questions yet unsolved and to enable them to aspire to teach children, to practice medicine, to start their own company, to design planes or to make music.

This book project came out of a desire to find answers to the age-old question that all of us, as parents, ask our children about their school experience "What did you do at school today?" This question is more than an urge to satisfy our idle curiosity but a query into who our children have become at school, what they believe, and how they learn. Are our schools places of alienation or communities of support? Enclaves of safety or territories of hostility?

Do our schools teach that *En Los Ojos* is the hope of our families?

At home with my own children all I may do is ask about their day at school, but at work as an educator it is my obligation to create schools worthy of the hope that parents entrust to us. Furthermore, as the Director of Educational Technology, I work to create opportunities for students to use the digital tools of their world such as iPods, digital cameras, email, computers and instant messaging, to connect youth to knowledge and people who will awaken student potential. Even though I hope that the work we are doing in education is helping our children, an event occurred that disheartened me.

I sat on a small folding chair at a linen-covered table with seven other educators. The room held 15 or so other tables with superintendents, administrators, vendors and university professors sitting in familiar, circular configurations. We waited for the lead researcher to begin her presentation. She began a PowerPoint slideshow of charts, graphs and educational statistics. Each slide presented statistics creating a bleak picture of K–12 education in California. At one point, I closed my eyes and pictured the hundreds of tables that I had compiled from thousands of scores from millions of students. I had worked with a second researcher, Crista, to do statistical formulas on countless data sets to help the presenter develop the charts and graphs that we were all seeing. Fourth graders score in the 30th percentile nationally in reading—dissolve to next slide. High School Students score below the national mean on SAT scores—fade to next slide. Middle school students score below the National Percentile in reading—dissolve to next slide. Computer ratios in California are below the

national average. The bright colors seemed to change to a grey hue and the pale pigment on the screen absorbed whatever light that sparkled from the audience. The presentation finally came to an end and a moderator came forward to ask us to discuss what we had seen and heard. The group members turned to each other and sat staring for a moment during an awkward silence. Finally, somebody said, "Is that all there is?" The other researcher who sat across from me said, "There was more but it was not included in the presentation." Crista continued talking and tried to give the group some direction by commenting on the slide that showed poor technology use; that is, only 25% of teachers integrate technology into the curriculum. An administrator looked at her and asked "Does it really matter?" She was referring to the use of technology in the curriculum. I could not help but think that she might be referring to all the slides of research statistics we had just seen. These damning statistics had left us numb, and we recoiled from what we heard. All the statistics we had completed were insightful but not helpful (at least at that moment). I remember leaving the room feeling confused about the overwhelming problem that California faces in education.

Fortunately, I had another experience that helped me to refocus my efforts. I was attending a workshop with Marty, a colleague of mine, at a technology conference. Rick Smolan, the creator of the photography books *America 24/7* and *A Day in the Life* series, was the speaker. The workshop started in darkness. Photographs began to sharpen on a large screen that covered the stage. On a rock, surrounded by green grass and shadowed trees, a little girl stood barefoot on her mud splattered tiptoes. The picture

faded and another photo appeared of a man, high above New York City, precariously perched on an art deco masterpiece, dangling from the top of the building, changing a light bulb. One slide dissolved and another replaced it.

After the show was finished, Rick Smolan took center stage and he spoke of how this project began. He was tired of hearing how the world thought of America with disdain, and he was weary of the images that the news media showed of his community. He decided that he wanted to tell his story—the story of how he experienced America. He proceeded to organize 1,000 professional photographers and asked people across the nation to shoot and send him photographs of their experiences. He and his team reflected on those photos, gathered a group of colleagues and created the photography project that would become the book *America 24/7*.

As I listened to this, my own excitement began to swell as I saw the possibilities for education. The authors, photographers and creators of the *America 24/7* project explored America through the media of images and words. They had learned about their nation by examining the experiences of thousands of Americans and then had an opportunity to synthesize those experiences into their story. This book had given these men and women a voice to speak to the nation, inspiring hope in them and in me.

It struck me that our youth need an opportunity like this to learn through the telling of their story to a community that could awaken their aspirations. For as one collaborator, Kris Kemp, wrote, "Technology not only enhances our school's curriculum but can also help us to better understand ourselves in a satisfying revelation that answers the clarion call of the digital age."

From that experience, educators from California State University, Pomona; California Technology Assistance Project, Region 11; and the Covina Valley Unified School District organized to create the project *My So-Called Digital Life*. Two thousand students from 32 middle and high schools across the state were given digital cameras and were asked to document, in digital photographs and words, their day-to-day worlds. These schools ranged from Avalon, a school that served students from kindergarten to twelfth grade on Catalina Island to the Phoenix Academy, a program for students with substance abuse problems. Each class of students, including their teacher, was paired with a professional photographer and several college students from California State University, Pomona who mentored the teenagers in narrative writing and photography.

As a part of the event, some students were bussed to schools in different parts of the state, including inner cities, and rural and suburban areas on a week-long field trip intended to bring students together from diverse backgrounds. Professional photographers, teachers, and videographers accompanied and advised the students throughout the week-long trip, as students photographed and wrote about their beliefs, feelings, and thoughts concerning their education, their community and themselves. All of the students were able to communicate with each other over the internet, sharing their experiences in text, audio, and digital photographs. Next, the 60,000 photographs were distilled down to 358 images for the book. At the conclusion of the project one class of students from Northview High School and their dedicated teacher, Dennis Jose, spent hundreds of hours designing and compiling the book.

Through the 30 days of the *My So-Called Digital Life* project, the kids often commented about the irrelevance of school, and my tendency was to dismiss some of their comments as simply words from those unwilling to do the work necessary to learn. However, after viewing all the photographs, reading close to a 1,000 essays and 2,000 blogs written by and about students from diverse socio-economic and ethnic backgrounds, I found the truth in what Gary Anderson, an educational Researcher from New York University, wrote "Children are experts on their own lives." After being privy to the fears and concerns of so many students, I could not ignore the comments of so many youth.

One student wrote, "Who wants to spend hours finding answers out of text and just copying it down? It has already been written, why write it again?" Another student wrote about "how dull and lifeless school seems to be. Technical ways of study are stressed such as copying notes and reading from the textbook." These student critiques may be a reflection of the change that has occurred in our educational policies and goals. Thomas Jefferson wrote that education prepares students to become fully participating citizens to advance democracy and to prevent tyranny.

After Russia launched Sputnik, the first successful space satellite, a national agenda was set forth for schools to create science and math programs that would give students the background knowledge, problem-solving skills and inquiry processes needed to find a way to put a man on the moon. However, our current national policy has defined education's purpose as improving student achievement in the basics as measured by standardized exams (usually on multiple choice assessments) so that all students are proficient. Our national agenda for education seems mediocre in comparison to previous admirable educational agendas.

One student captured this best when he wrote "Inspiration is painfully overlooked. Countless examples could be brought up of that enthusiastic spark disintegrating in students. Truly there is often no point in learning. . . . Students begin to question themselves, their abilities and potential."

The irrelevance that some students feel at school is often overshadowed by the violence and fear they feel by the gangs, drive-by shootings and drugs in their neighborhood. One student wrote, "My neighborhood isn't the safest place to grow up for me and my two little brothers. Violence, gang members, and drug dealers are very common where I live . . . making it hard for students to learn." Another student wrote about his nightly neighborhood experience: "I was scared because I heard screams, shouts, and even crying in the middle of the night. I was scared at that time." It was apparent that the dangers and difficulties that the youth encountered often encroached on the subtleties of the facts and information learned at school that may or may not be useful to them at universities that they may never be given the opportunity to attend. As students encounter gangs, drugs, drive-by shootings and violence, students may feel that finding answers in a textbook, filling out worksheets, and doing test preparation for multiple choice exams may not be enough to adequately prepare them to face the realities of their lives.

The violence in students lives became poignantly real when Linda, one of the teachers whose class was involved in *My So-Called Digital Life* wrote to me that Keion, one of her boys participating in the project, was killed on February 7, 2005 by a drive-by shooter. Ironically, on the day I celebrated my birthday with friends and family, the boy died on a street corner without his family there to comfort him. I don't know if it was that ironic twist that acted as a catalyst, but something changed inside me. I found myself experiencing tremendous grief that stayed with me throughout the day and followed me into my dreams that night. I kept thinking of the boy's mother and how her son had been taken from her. With sorrow and gratitude, I appreciate what Keion helped me to see. These students in this project are your sons and daughters and on that day they became my kids too. I really got to know the kids from reading, listening, viewing and responding to the thousands of messages from them. It is with humility that they shared their concerns, fears, failures and successes. I got to see in their images and writings that our kids have such good hearts. They worry about you when you work late at night, they try so hard to make you proud of them and they feel tremendous sadness when they disappoint you. Our sons and daughters want their lives and learning to be meaningful. As parents, we want this same thing for them. For *En Los Ojos*, they are the hope of our families and our nation.

Through our hope, we can create schools that are able to prepare our students to one day cure cancer, to secure our national safety during a time of terrorism, to be the first nation to put a man or woman on Mars, to find a renewable source of energy, to bring democracy to places ruled by tyranny, and to create communities of prosperity and compassion. Surely, selecting the right answer from a multiple choice exam is something that we want our students to know how to do, but is that enough for our nation and our children? Our sons and daughters have voiced that they want more from their education.

—*Bob Pletka*

before and after school

Not to touch the Earth
Not to see the sun
Nothing left to do but run, run, run
Let's run...

Every Wednesday my CD alarm goes off and Jim Morrison and the Doors open with a song, which drives me out of bed. It's seven-fifteen in the morning on our late-start day. Ahh...the beginning of another day. On Wednesdays school does not begin until nine-thirty A.M., as opposed to the typical eight o'clock start. I stand up, pop my back, and listen to Morrison screaming wildly in the background. Despite his wild, bizarre, and often drunken sound, Morrison's meaning is clear: People today are busy and stressed, often to extremes. People feel that there is nothing left to do but run. Next thing I know, my father is driving me to school. He clicks on the radio and Freddie Mercury's static-edged voice fills the truck:

> *Pressure*
> *Pushing down on me*
> *Pushing down on you...*

How true is that? It seems that musicians have the best methods for bringing out emotion and encouraging thought. In a way, I can almost see the crowd roaring and dancing in front of the stage, conjuring a cloud of pure energy. What a way to live. Listening to music and simply having fun. Too much happens now. Stress is placed on kids for things like academics, and sports, along with influences such as peer pressure.

Anabelle Morones

When the music is your special friend
Dance on fire as it intends
Music is your only friend
Until the end...
Until the end...
Until the eeennnddd...

"Adam! Pay attention, please!" my biology teacher snaps. I sit upright, suddenly awake. Doors' music no longer echoes through my mind. Truth be told, I don't find biology to be the most interesting subject, and I'm not surprised that I was drifting off. Some teachers, intentionally or unintentionally, stress me out. Sometimes all they have to do is look at me strange to worry me. Teachers who apply constant pressure on their students

Background image by Janet Guan

It's always a mad rush to get from the bus to the first class of the day. The students are in such a panic when they arrive to campus that sometimes they trample each other getting off the bus. There is always lots of traffic around school in the morning and after school. Because of the traffic, the bus in the morning is often late, making the students late as a result. The bus ride in the morning always adds a lot of frustration to my day because I never know if I will make it to school on time or if I will get in trouble for being tardy. I have to wake up at 6:00 A.M. just to get on the bus in the morning and I have to deal with all the noise of the immature students. 100 years ago students walked to school, and never had a bus system to complain about.

— **Ian Kovalsky**

We all have routines which we usually live by. This is a picture of me going home while going on the bus. This process takes about 50 minutes. During this process I just think about life and the things going on. Sometimes I think about school. It gets boring sometimes but I enjoy the peace and quiet of the bus because home and school are both hectic places. Then when I get home I only have a couple of minutes to relax and then I have to do chores and a lot of house work. The bus is where I relax the most.

— Eric Escobar

can drive them up the wall. Grades aren't much better. Always, I try to raise that grade. I look down at my assignment sheet and notice that my grade has steadily declined from a high "A" to a "B+." It's not just the B that irritates me. It's that antagonistic "+." It haunts me and mocks me, hinting that I'm almost good enough for an A, but not quite. Almost. All I have to do is "Break On Through (to the other side)." The bell rings and the whole class heaves a sigh of pure relief. One class down, five to go.

> *Let's swim to the moon*
> *Let's climb through the tide*
> *Surrender to the waiting worlds that lap against our side…*

Swim practice began at four o'clock today. We've been doing 400IMs and I've been lapsing into a semi-conscious state every now and then, singing the lyrics of "Moonlight Drive" in my head. I always have music playing through my head during practice. It seems to make the sets easier and the time go faster. Even so, I can feel myself tiring from the butterfly. Every time I look up, I see my coach screaming something in my direction. Most likely, "Faster! Faster!" or "Go, Adam, go!" I can't help but smile, and I increase my pace just enough to satisfy her. That should calm her down a bit. A good coach can leave a great impact on teens, but they can push too hard sometimes. Constantly, they force athletes to go harder and faster than they should.

> *Nothing left to do but run, run, run…*

Usually I can cope with these requirements, but every so often I lose my patience. Coaches will push students to the brink of a major injury if they are allowed. Is winning so important that we are willing to sacrifice another person's physical and mental well-being to achieve victory? Must we push mere *children* to their limits in order to win? I don't approve. As I mature, I realize that there is more to life than just working. If we work all the time we are no more than walking, talking images. It would be difficult to call such an existence "life." As Jimmy Buffet said, *"I'd rather die while I'm living than live while I'm dead…"*

Background image by Ryan La Com

Well, most of us try to forget the days of saving seats, and getting to sit in the back of the bus because we thought we were cool, but, eventually, those days creep up on us like a pop quiz. Your friend bails on you, and there you are left without a ride. "Mom please pick me up, I don't want to ride the bus." Kids shout profanities, make out, talk about there newest PS2 game, and worst of all, a lot of them reek of BODY ODOR!
— **Dennis Williams**

It is 6:40. I'm on the bus to school. The moon is still out, stars still slightly visible through the ambient haze. The sun will break the horizon somewhere between now and my arriving to school. Having awoke at 5:40, I have had an hour to get through my morning regimen, and walk three quarters of a mile to the bus stop. Not fully awake, my first few hours of being awake pass in a semi-conscious haze, my body trained to autopilot me to school.
— **Kevinjeet Gill**

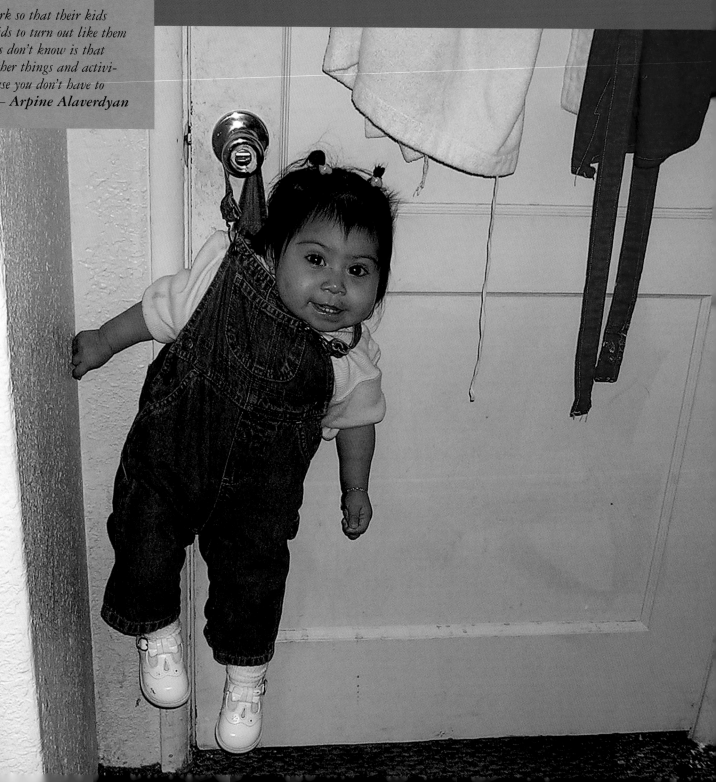

Parents like to stress-out their kids on schoolwork so that their kids will have a future. Parents don't want their kids to turn out like them and live such a hard life. But what the parents don't know is that their kids need some time to play and explore other things and activities. By playing you get a lot of stress out because you don't have to worry about anything.
— **Arpine Alaverdyan**

This is what I would like to do when I'm babysitting and supposed to do my homework at the same time.
— *Jose Montano*

Peer pressure also plays one of the biggest roles in a teen's life. Teenagers are constantly being pressured to do things like drink or do drugs. Unfortunately, many people fall into that crowd. Close friends dissolve out of view until they finally disappear. Everyone has to be original, but they have to conform to certain standards to do so. Everyone must either fall into a particular clique, or otherwise remain a loner. Finding a girlfriend or boyfriend seems unavoidable. It comes to a breaking point where it feels like absolutely everyone is watching you.

People are strange, when you're a stranger...
turning their heads every time you look their way.
Faces look ugly, when you're alone...
When you're with a girl,
Women seem wicked, when you're unwanted...
you can't be yourself,
Streets are uneven, when you're down...
and it seems to eat you alive.
When you're straaaannngggeee...

It's during situations like this that I realize the truth hidden in lyrics such as "People Are Strange" by the Doors. Everything adds up, and pressure builds until it is somehow released.

Sittin' on the dock of a bay
watchin' the tide rollin' away
Sittin' on the dock of a bay, wasting time
I left my home in Georgia
headed for the Frisco bay
I've had nothing left to live for
looked like nothing's gonna come my way
So I'm just sittin' on the dock of a bay...

Now as I lay in my bed listening to Otis Redding sing, I think about what I'll do after I graduate from Sonora High School. Maybe I'll get into a good college and make good friends. I've got to find my dock in the bay. But for now, I'm just waiting for sleep to bring me to tomorrow's doorstep. Sleep is the one way to escape the stress and pressures of the day. I guess Freddie Mercury was making an important point, wasn't he?

— *Adam Jorge*

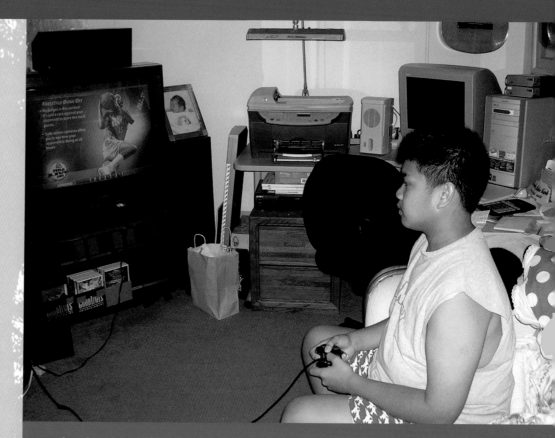

This photo is me after a long day at school. School is about seven hours long with lots of work. I need an outlet after I'm finished with my homework. I like to relax while I'm playing video games. I am here relaxing in my playroom with my Play Station 2. It is really my sister's PS2, but she lets me use it. This game is NBA Live 2005 and it is one of my favorite games.
— *Francis Inocelda*

Yvonne Ramirez

Background image by Angie Ruiz

We arrive early in the morning to commune with our peers before the first bell. First period, second period, the day proceeds in uniform according to the merciless ringing over the PA system. Nearing the end of the day, joyous laughter fills the campus as we realize our ordeal is almost complete.

— **Jeffrey Stonerook**

Crystal Hernandez

Background image by Adrian Juarez

Ani Akopyan

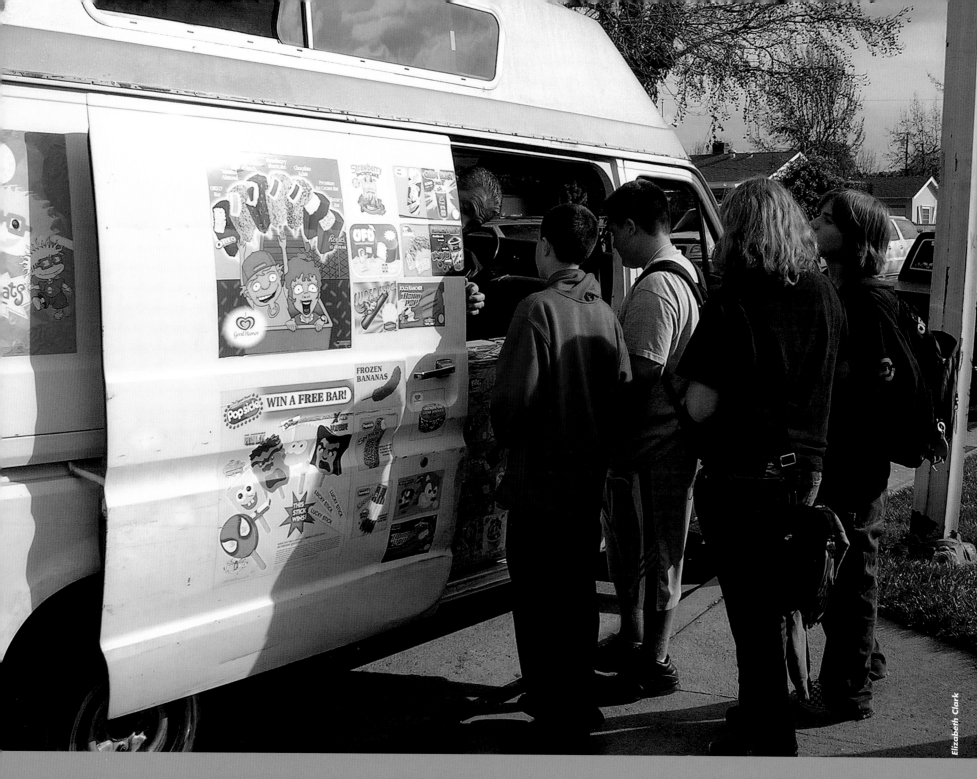

Elizabeth Clark

Students scurry to their lockers and prepare themselves to be subjected to a hopeful fun day of learning! Our personal opinion is that school starts too early for students to meet maximum performance in the class-room, especially for those with zero period, which commences at 7:05.

— *Elizabeth Clark*

Shannon Rainey

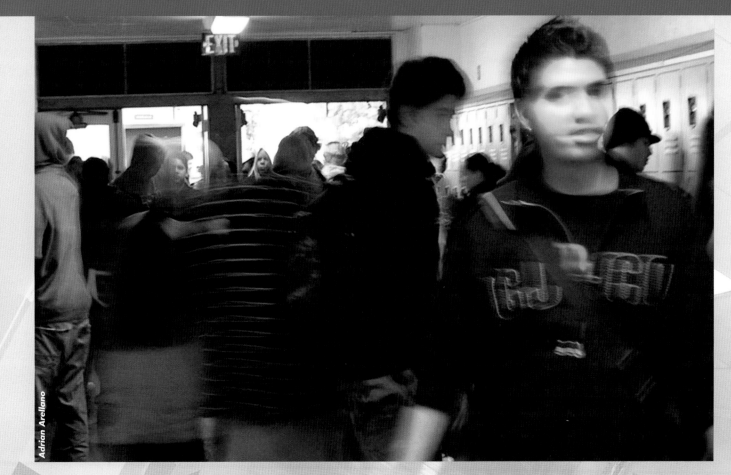

Adrian Arellano

Cesar Rodriguez

As students take the step from elementary school to high school, many things change. One of the most apparent changes was the change in the use of time before and after school. In elementary school, it used to be that you would hang out on the playground, shooting hoops or jumping rope. Then came high school. It was suddenly "not cool" to do those things, as they were considered childish. Even decades ago that was what the kids did, including high schoolers. Free time in high school seems to have become a social stand-around time, as opposed to the exhausting activities of elementary school.

— *Robert Carter*

Background image by Christina Mejia

High school is whatever we make it to be, and we all want our high school years to be memorable. It's not the portable buildings we will remember, but the people who help to shape our lives.

— **Jennifer Venhuizen**

Hanna Crosby

Anthony Alvarez

Andrew Yu, a student at Alvarado Middle, reaches out to open his cold metal locker before school. After school, he will do the same when the locker is warm from the afternoon sun. Going to your locker is a daily routine for everyone at my school including me. Reaching in, we either put away our backpack or retrieve a utensil for our next class such as notebooks and textbooks. No one else is around him which probably means he is late. He can't just go straight to class with his backpack because we have a backpack policy at our school: you aren't aloud to bring backpacks to class. It is a safety hazard and it's very easy to follow.

— **Danielle Nuezca**

My parents come from a really poor family. They were born in Mexico. My mother said that when she was a little girl she wanted to go to school but that her family couldn't afford it. My mother had to work since she was seven years old. We want to make our parents proud and show them that when they risked their lives to come to the U.S. as immigrants, it was worth it. Unlike most kids, my brother, Hugo, does his homework everyday. He is already thinking about his future. — **Rogaciana Sanchez**

Pedro Tomas

Karla Nieves

Carlos Ruiz

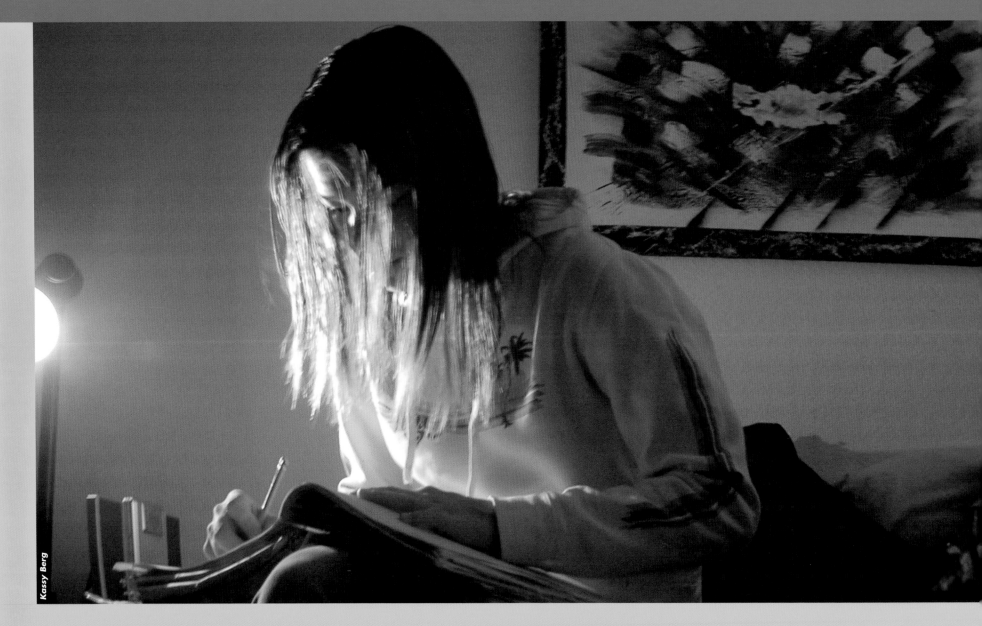

Kassy Berg

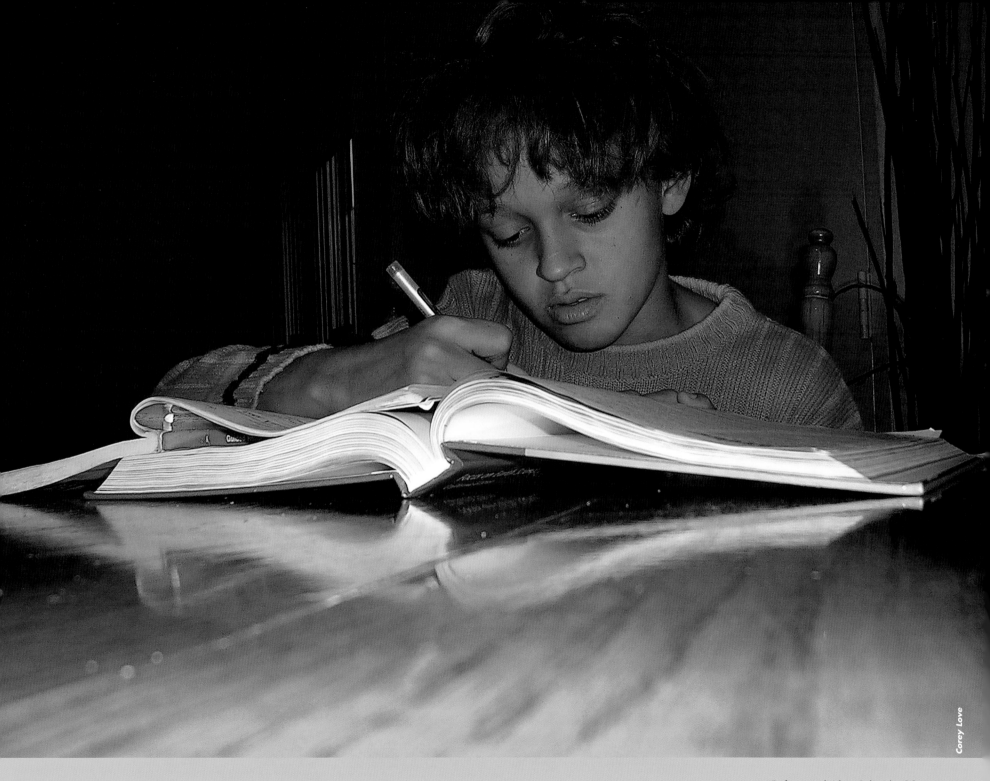

Corey Love

We are at school to build our foundation for the future, but for those of us who spend our years hating school and partying, the foundation is built on negativity, and it will crumble under the pressures of college and life.
— Lindsey Kearney

Corey Armend

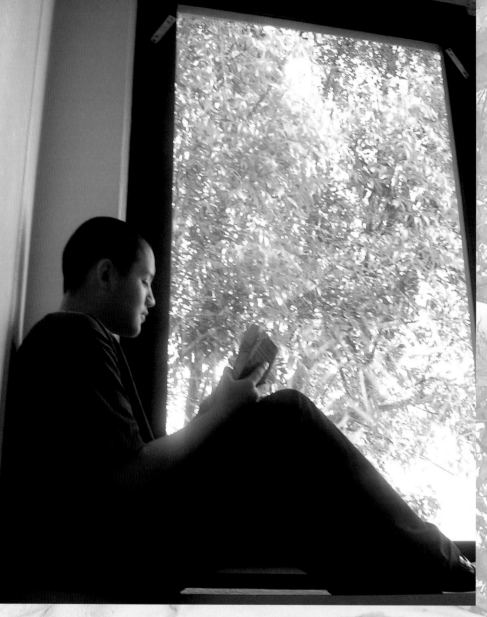

After school I like to read. Reading helps my day go by faster and easier. Sometimes when I'm really upset, I can rely on a book to help me calm down. When I read my book it gives me time to think and relax. It makes me forget where I am at that very moment and also forget, for a time, how I got here. Before I came here to the Phoenix Academy I never liked to read books. I hope that I can keep up my habit of reading before school and drop most of my other HABITS after I leave.

— Jesus R.

Background image by Walter Jimenez

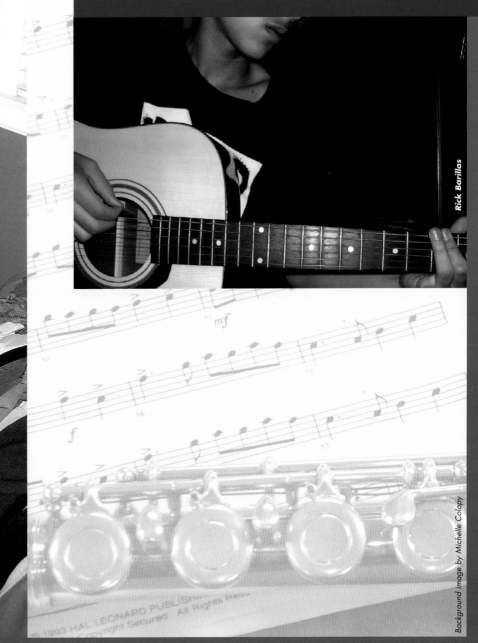

While other people like to sit and talk, I like to hang out and play guitar, usually with my friends. The coolest part is the companionship, having other guitarists stopping by and showing me something new, or maybe showing my friend a new song or sharing a tab and have him learn something new.
 — *Andrew Love*

Rick Barillas

Gregg Allen

Background image by Michelle Colopy

Their faces seemed to be completely emotionless, but, when I looked closely, I could catch a smile playing at the corner of every musicians' mouth. Their eyes would dance with joy; their bodies were held with pride. This was the main spectacle in every parade, the pride and joy of our area. This was none other then our local high school band.
— **Annemarie Mustin**

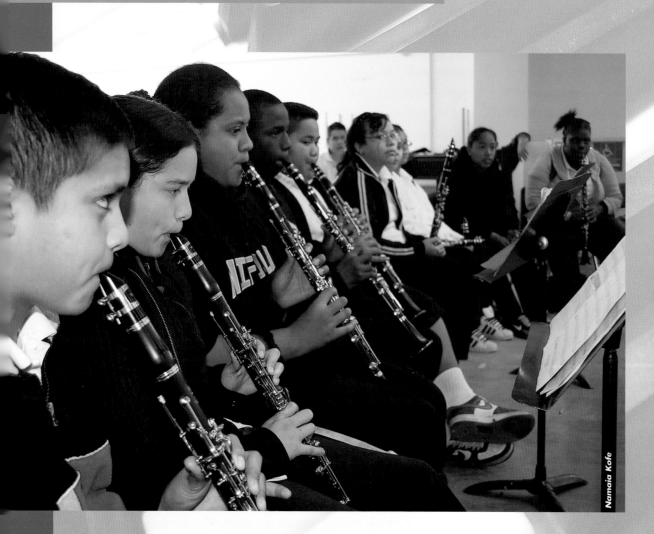

Namaia Kofe

Background image by Kerry Leong

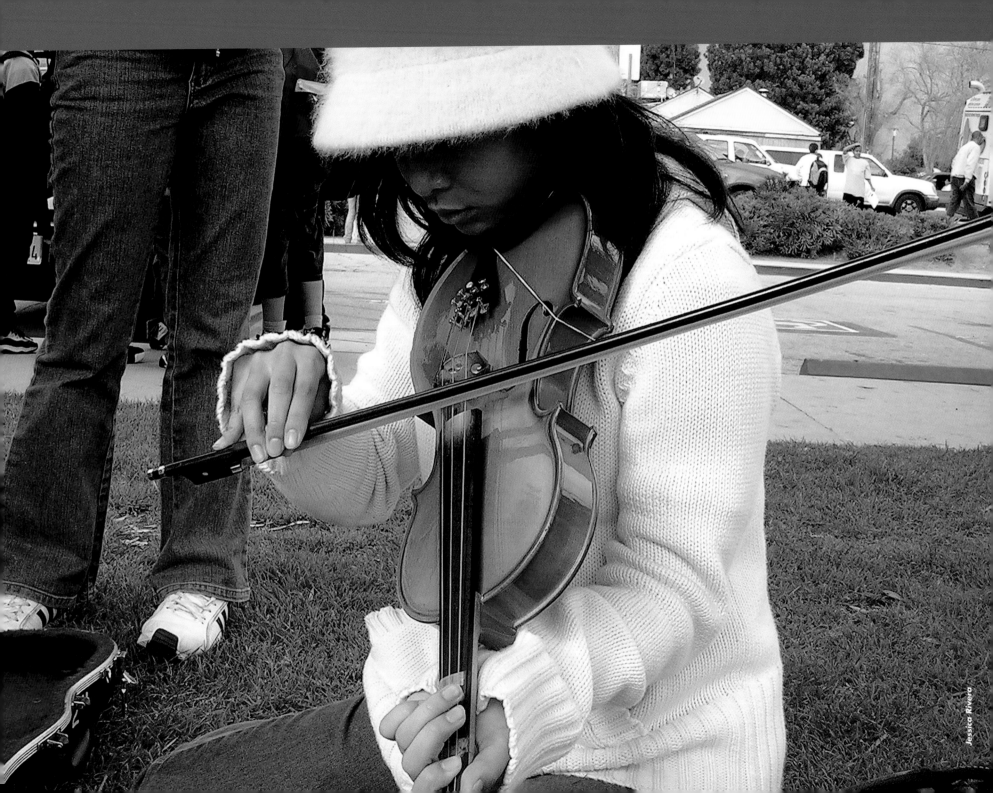

Jessica Rivera

Students like to compete against each other, whether it's on the court or in the classroom. In the classroom, there's not as much screaming. But out on the court, look out! Often you can hear the screams of players missing a shot, falling onto the court, or just screaming at someone to get out of the way. It always gets crazy out there!

— **Elizabeth Lara**

The football team starts conditioning for the upcoming season early on in the year. They get together before and after school to do weight and agility training.

— *Kate Boland*

In this photo you can see that sometimes after school, I can go to the weight room to lift for a while. As I concentrate on my technique, I can lose my thoughts in the process. It helps relieve stress and to build up my endurance, which is something we all need to make it through our programs. Sometimes I can envision the layers of my personality unrolling in front of my eyes, just like in the picture.
— *Michael J.*

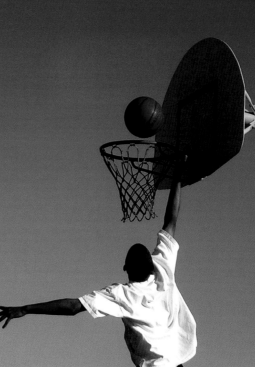

Who said middle schoolers can't dunk? I know I didn't. Many eighth graders are so close to dunking, they will practice and practice all day and wish that they will dunk tomorrow.
— *Marco Mravic*

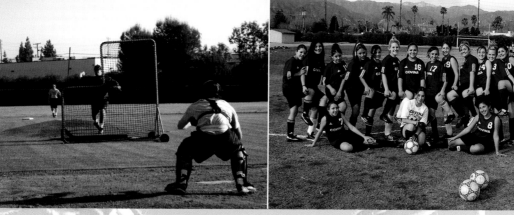

Araceli Valencia

Amanda Gutierrez

Background image by Sabrina Johnson

*many ways, but I believe that we don't look at
e get when we are "wasting time."…. I looked up
and I noticed that there was one dark cloud
tronger. Finally, it finished off all the white ones
k and gloomy. Out of nowhere, the clouds showered
ow wonderful.* —**Joseph Won**

Kayla Hendrickson

Alison Mok

Brianne Hartshorn

Albert Miranda

Nakul Bhatnagar

Often, I feel like I am all alone and there is nobody around that understands me, at least nobody my age. I often find myself alone at times when everyone else is with friends.
— *Becky Cobb*

It has a warm atmosphere with the rich smell of coffee and mochas filling the air, with the taste of those sweet sugary pastries in the cases and with friends talking and people working it is oh so comfortable.
— **Cate Gorton**

Shameca Johnson

Anna Campos

Ruben Amiragov

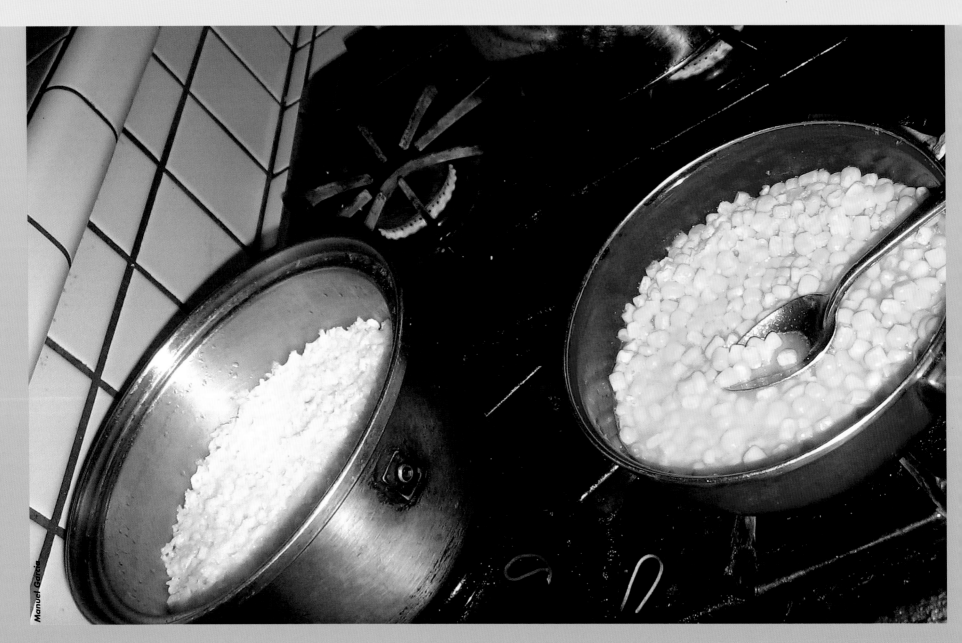

Manuel Garcia

Jason Wu

Nakira Stepter

Students have been thriving under the wings of their parents and suddenly there's a demand for the abandonment of their sheltering niche. It's not yet apparent why their world is to be revolutionized. Some are fed up with authority; some feel independent; others wander in circles for answers. What could be more fragile than a developing mind on the brink of a revelation?
— **Ruben Amiragov**

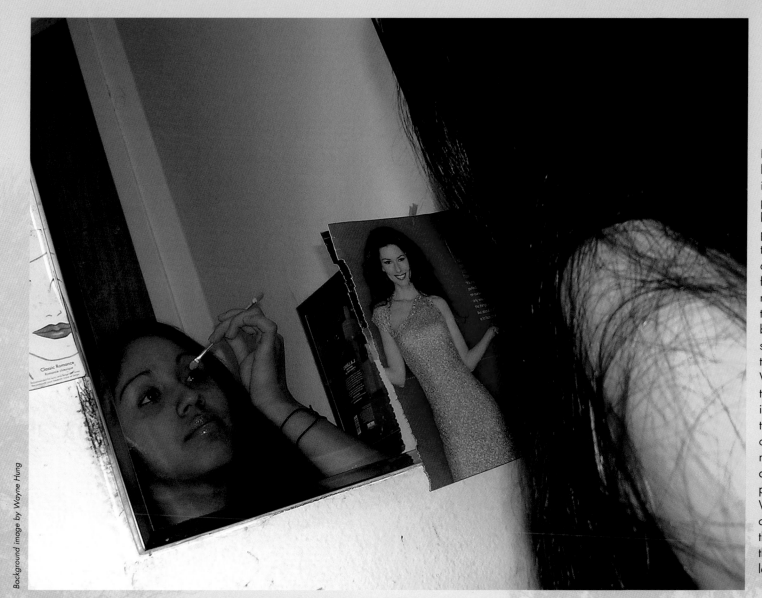

Background image by Wayne Hung

Here's a girl who is trying to be as beautiful as the woman in the magazine. She is comparing herself to the woman because the model is very pretty. She will never be able to live up to this false image and is setting herself up for failure. Most girls think that models set the standard for the way to look. Many believe that because they are skinny and gorgeous, that they should be admired. What they don't realize is that beauty comes from within. Our everyday life here at the Phoenix Academy starts off with us looking sharp and not sloppy. They feel our bad dress code on the streets is part of who we used to be. What they are trying to do is change our old behaviors, so that we won't fall back into the same habits when we leave the program.
— *Amber M.*

Amid fears and skepticism, youths find time for glee. Submerged in an environment teeming with like organisms makes these mind storms worth their while. These kids experience the full spectrum of emotions, often disregarding school as their muse. — **Ruben Amiragov**

Daniela Martinez

Background image by Amir Pouyavand

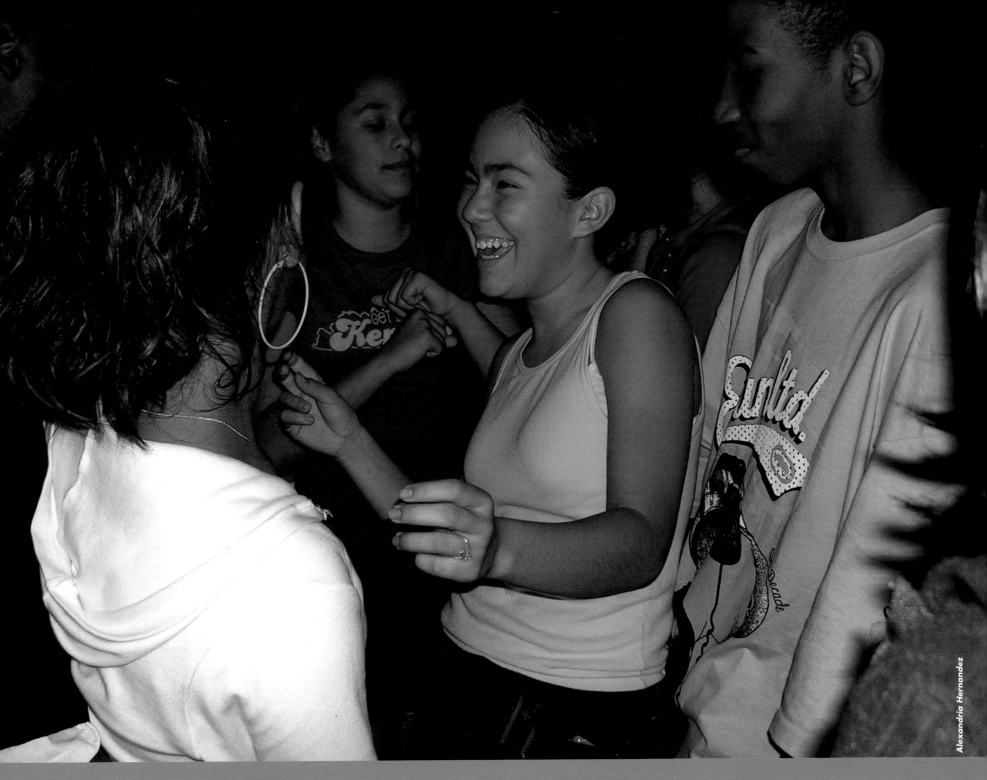

Alexandria Hernandez

Teenagers, like me, spend their time after school doing chores in the house. Because my parents work late, it is my job to take care of the house until they get home. After I do the day's dishes, I eat and start my homework and then I wash some more dishes. My parents want me to be someone in life so one day I can have a better life than they do.
— **Karen Castro**

Part of being eleven is learning to be more responsible. I am learning to be responsible in school and at home. After school I do homework and chores.
— **Ivan Oliva**

Background image by Han Lee

Every Thursday our school starts at 10:15 A.M. Because of this, I go to work with my mom in the garment district of Los Angeles. I work with her from 7:00 A.M. to 9:30 and then I go to school. My mother is sewing and I am cutting the straps of the blouses. In my lap, I am holding the ones I have already done.
— **Jessenia Banegas**

learning in the classroom

When you think of a typical learning experience in school, what usually comes to mind is being surrounded by four cream-colored walls, sitting uncomfortably in a stiff desk under fluorescent lights. Your eyes wander the room and land on whatever your thoughts drift away to next. Fighting the conversation at the back of your head you force yourself to focus on the lesson being taught at the front of the class.

Depending on your learning style, you may do best with lectures and note-taking, however many people are hands-on learners. Most schools have now eliminated useful courses such as autoshop, woodshop, cooking, and sewing, as if the need for these things has vanished. It's true that my generation doesn't need to rely on ourselves to do the work that machines have conveniently taken over. But these were the original hands-on courses that taught our grandparents the physical and mental skills they applied to their work and everyday lives. These classes allowed students to learn in a more personalized manner. Opposed to writing a report for their history teacher, they could work on their car or bake a batch of cookies for their friends.

It has been said that we learn on a need-to-know basis. My experience from this project has proven this true. I witnessed my classmates rummaging through the thesaurus at 9:30 on a Friday night to better enhance their narratives in an effort to improve their chances of being chosen. In *The Art of Looking Sideways*, Alan Fletcher says "The fact is that the mind thinks with ideas not information, so acquiring knowledge is useless unless one learns how to use it. A dictionary

Kyle King

may contain all the words but no one can tell a poet which to choose or what to write." Whether it is doing science labs, painting in art class or just the mistakes I've made in the past, I think my experience verifies this premise.

If we are taught all the languages of the world but never speak any of them we will soon forget how they sound. Just as I've forgotten many of the scales and inversions from my music theory class last year because I haven't played piano consistently since. We cannot afford to not use the knowledge we obtain, otherwise it will dry up and we'll eventually forget all that was there. We must practice and utilize what we are taught, which will in turn give us more insight into what we

Background image by Alejandro Campos

Aside from the student, the most imortant objects for learning are illuminated—everything else is lost in the darkness.
— *Meagan Chin*

After every tiresome period of having facts fill up her brain, an exhausted student pulls out her pink velvet pen and jots down her homework for the day. She repeats this routine every day in every class so she won't forget the homework that is due the next day. To help us with this, Alvarado provides each student with a school planner and the teachers sometimes check to see if we've written in it every day. — *Y-Lan "Laney" Tran*

I wanted to express how dull and lifeless school seemed to be. How technical ways of study are stressed such as copying notes and reading from the textbook.

— **Meagan Chin**

already know. All the book-work in the world cannot compare to the moment when the light bulb flashes in a kid's head and they make the connection that applies what they're being taught to solving the problem at hand.

For teenagers, what is being taught must have relevancy and a purpose. We need to feel like we can actually understand and relate to what we are learning. Hands-on courses in school help give reality to an objective that we can essentially achieve. In doing this E-maze project, I learned that I could give others a glimpse into what I experience by a simple click of the shutter documenting the life around me.

— *Kate Boland*

Background image by Olivia Walsh

Javier Ortiz

Noemy Preciado

Jasmin Esquivel

Our teachers do their best to help us on everything we need help on.
They stay after school until 6 o'clock in case a student needs assistance.
When I need help on something I just ask one of my teachers.
— *Lizeth Olivares*

At our school the teachers try to explain
their lessons with us in any way possible.
And they usually teach us on a one-on-one
basis. — *Christina Mejia*

Victoria Garcia

Daniela Alvarez

Yekaterina Novikova

Dillon Chaffin

This is a typical day at school for me, just doing boring work out of the book. I am in my algebra class that is very boring. As a requirement to graduate, each student must complete a year of algebra in high school. The math is not hard for me, but it is very boring just doing problems out of the book each day. There have been such advances in all of the other classes and textbooks, except for math; it is the same boring methods of teaching. If they could make algebra interactive and fun on the computer, then I think more students would be able to pass the course in high school. **— Dillon Chaffin**

Background image by Ana Flores

The most unappealing work is that from out of a book. Who wants to spend hours finding answers out of text and just copying it down? It has already been written, why write it again? — **Kelly Adams**

A Writer's Collection

A Writer's Collection

Caroline Salmeron

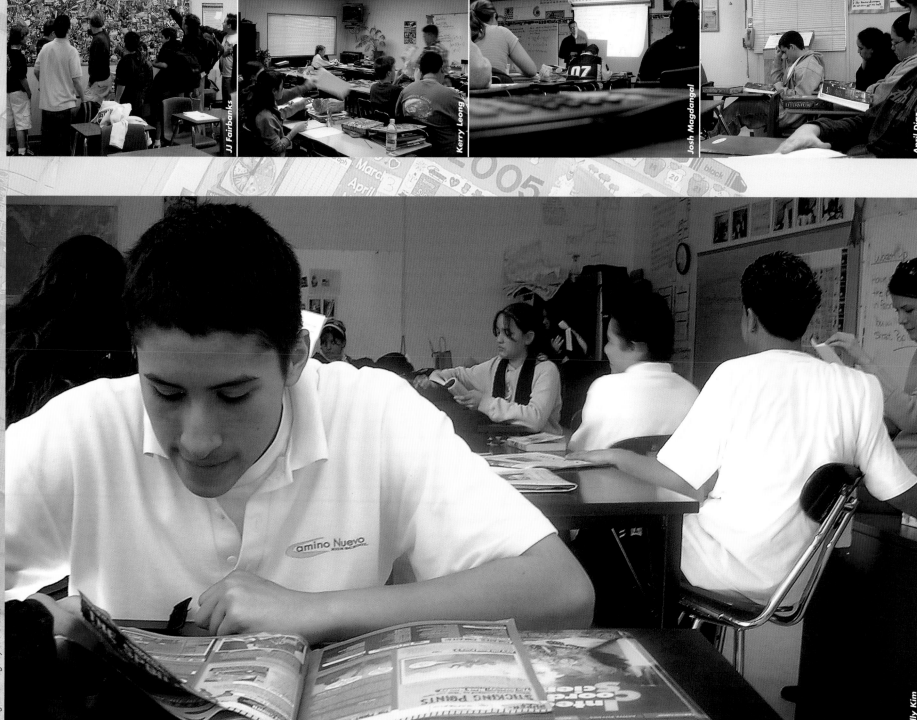

JJ Fairbanks

Kerry Leong

Josh Magdangal

April Diaz

Billy Kim

Background image by Luis Orenos

I don't impact my community as a result of my learning experiences. I know that I am a better person and a more tolerant person from my leaning, but that does not really have a huge impact on my community.
— **Eddie Weiss**

Christy Boch

Adrian Arellano

Daniel Alonzo

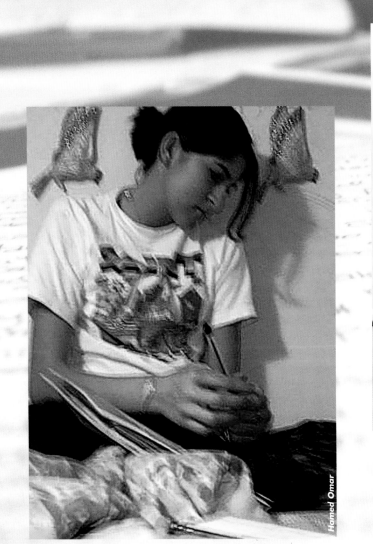

Hamed Omar

Background image by Danica Benitez

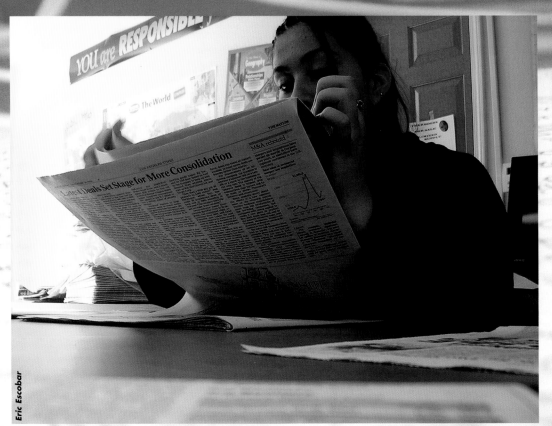

Eric Escobar

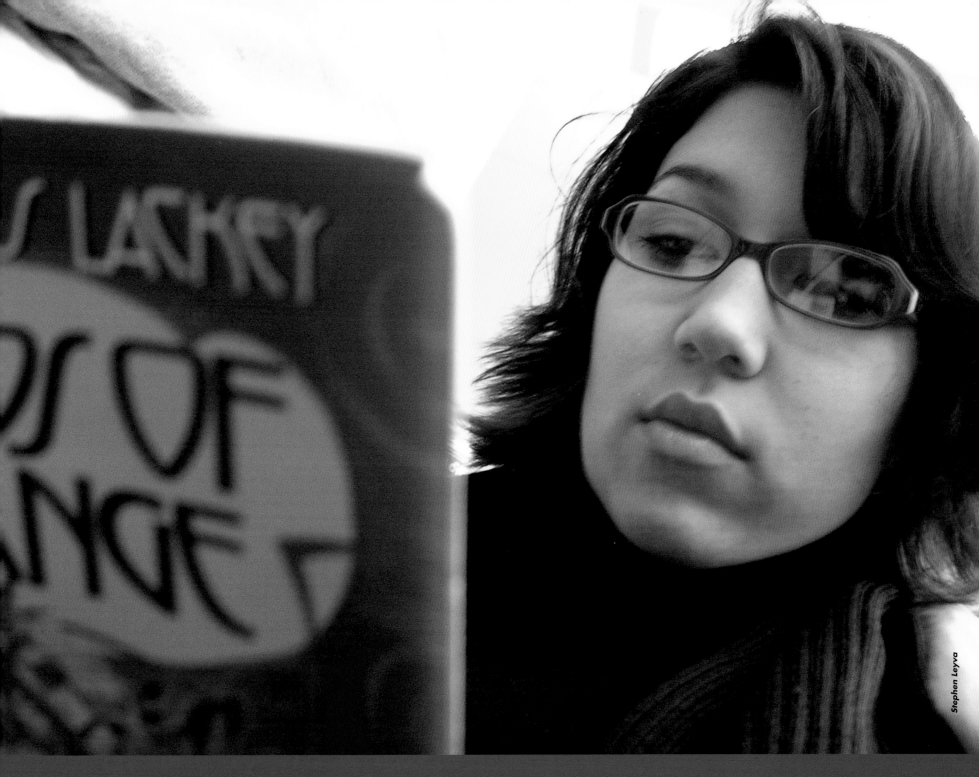

Stephen Leyva

Without art, there would be no innovation, there would be no fancy iPod, no highly contrasted pictures on your binders, and there would be no stencil on your shirt. There would be no literature, or math, or science, or religion, or need for a school without it. Without the inspiration to create, there would be nothing. — **Christine Byramian**

I play in our rock band in school, which makes school fun. We have a full studio going on, the drum set, guitars, bass, and mixers. Playing music in school is the best. I enjoy composing songs, as well as learning the music of other great artists. My teacher, Ms. Dean, makes us feel comfortable to express ourselves musically and also challenges us to reach higher levels with our play and writing. We are exposed to lots of different types of music as well as different types of technology to use to enhance our songs.

— *Jesus R.*

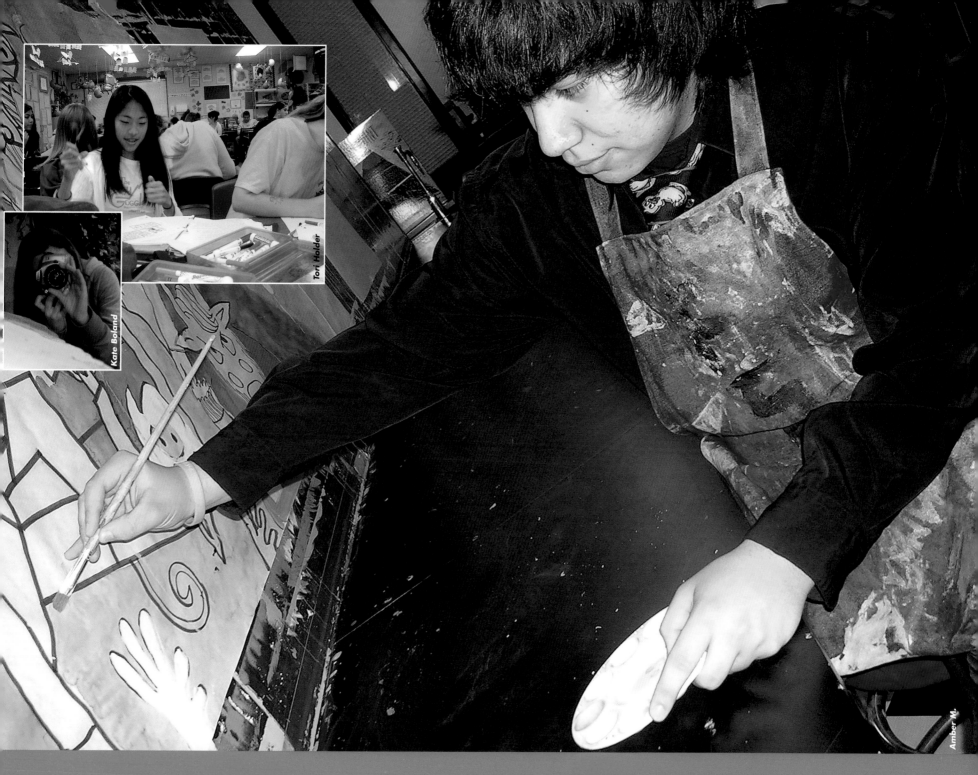

Tori Holder

Kate Boland

Amber M.

I think that learning in the classroom doesn't have to be only with letters and numbers. You can learn in an art class as well, but in a different way, the two students drawing a portrait of themselves is an interesting way to learn. They are improving upon the skills they already have, and that just helps them understand what they are doing more thoroughly. I think that learning is not limited to just one type; you can learn in so many different ways. **— Dro Amirian**

The school is a whole different community, and is also a part of another bigger community. Being involved with school and learning there helps enrich your mind with things that you'll use later in life. This small community helps prepare you for a bigger one.

— *Jackelynn Ho*

Lindsey Kearney

Angel Lopez

Sara Baek

Annie Zhang

ment, disorganized parties w
As a result, prime ministers a
In addition to its political in
nomic problems. Bloody peasa
same time, strikes and riots trou
the Italian government could not
problems. As a result, Italy entere

CASE STUDY: Germany

The Rise of Prussia
Like Italy, Germany also achieved na
Since 1815, 39 German states had for
federation. The two largest states, the
d the confederation.
several advantages that would eventual
of all, unlike the Austro-Hungarian En
As a result, nationalism actually unified.
ore it apart. Moreover, Prussia's army w
ly, Prussia industrialized more quickl

n Unification Like many other Em
r of the revolutions of 1848. In that y
ble Prussian king, Friedrich Wilhelm

1870 Franco-Prussian
France v. fan
France

1860

Background image by Joshua Carillo

Learning in the Classroom **51**

Classroom activities that go above and beyond the textbook motivate me to learn. A hands-on experience tends to be remembered for as long as a lifetime, while knowledge from a textbook only stays as long as we need it.

— **Jessica Long**

Silviano Lopez

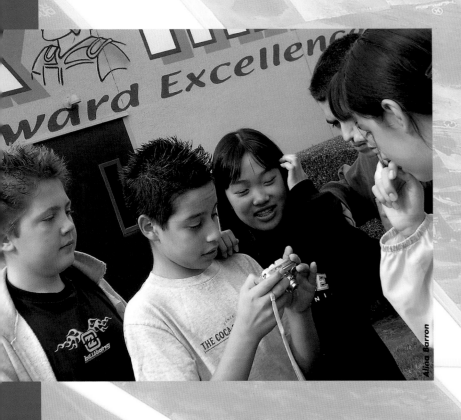

Alina Barron

Background image by John Cerda

The burning desire for knowledge has become almost tangible. This is shown by the recent fires at our school. Twice our lab has gone up in flames. So when you're working on one of your books, remember that knowledge is flammable. **— Travis Finger**

Travis Finger

Emma Anderson

5. Combustion

$CH_4 + O_2 \rightarrow CO_2 + H_2O$

$CH_4 + O_2 \rightarrow CO_2$

Prod.

React.

In chemistry class, Mr. Jernigan demonstrates the unique ways how different reactants will react with each other. In this lab experiment, he demonstrates the "combustion method"; nobody was hurt during the "flaming" experience (pun intended).
— **John Che**

I have noticed that most of my teachers do not even know what is happening in the back of their own classroom. The only interaction that happens during the course of the day is the teacher writing on the white board as you stare at the back of her head trying to hear the soft mumbles over the distractions throughout the room. — **Kelly Adams**

Evarado Lopez

Brian Angers

Jacky Yang

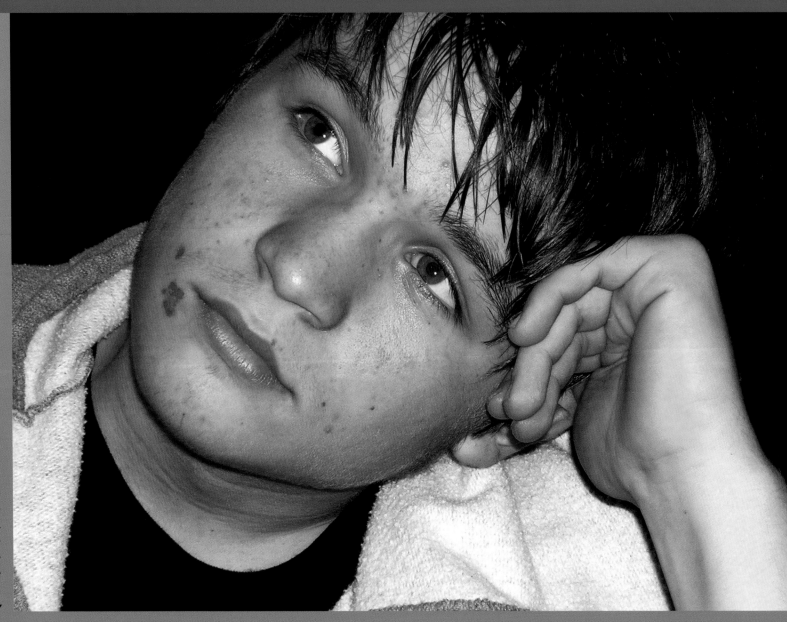

I picked this picture to represent our classroom learning. This picture shows a student staring into space as our teacher is going over easy concepts. Most students pay attention in class when others decide to doze off. Our classroom is usually very quiet. But sometimes we get out of hand and goof off.
— *Sean Mooney*

In the battle for teenage minds and attention, the lure of your own personal soundtrack often wins out.

— *Daniel Koval*

All subjects are monotones and inspiration is painfully overlooked. Countless examples could be brought up of that enthusiastic spark disintegrating in students. And truly there is often no point in learning materials presented in worksheets. Students begin to question themselves, their abilities, and potential. — **Ruben Amiragov**

Angie Ruiz

Amit Pouyanfand

Veronica Hernandez

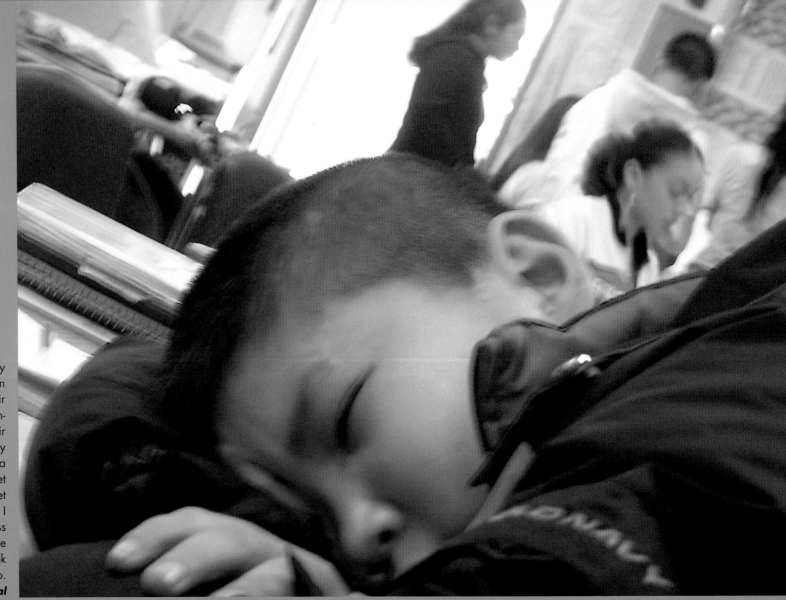

During language arts–history core class, Tony Nguyen sleeps while others do their work. Some sleep while others play around with their things. I sleep in some of my classes because I don't get a lot of sleep. I don't get enough sleep because I get too much homework. Also, I sleep sometimes if the class is boring like when you are reading from a history book and have nothing to do.
— *Sandeep "Sunny" Bal*

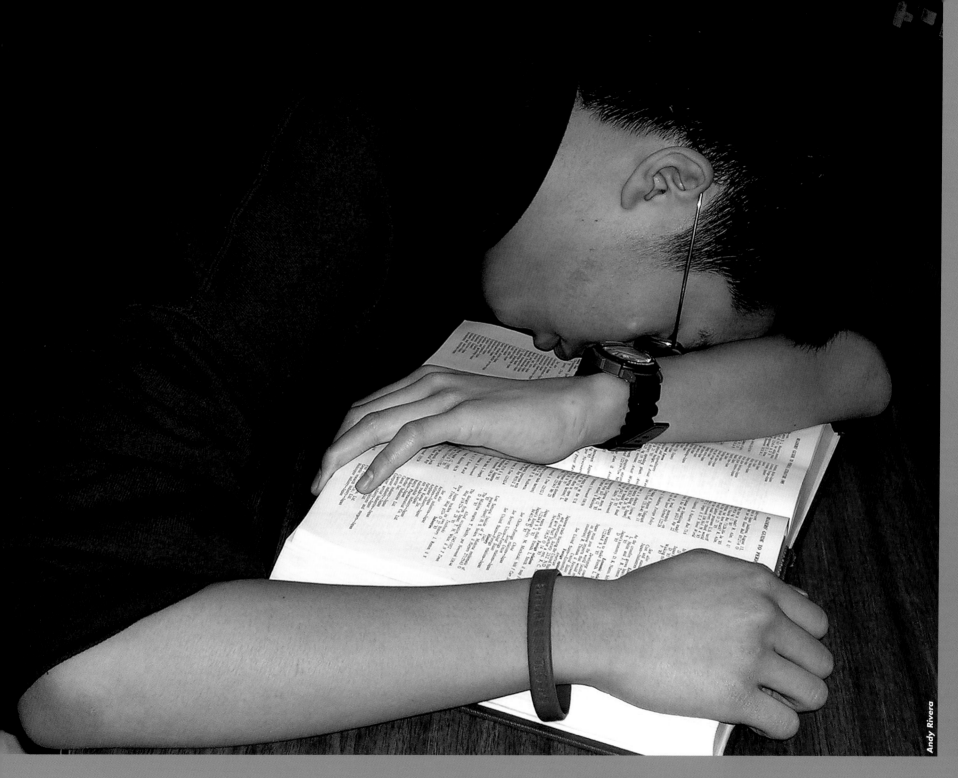

Andy Rivera

When the student cannot figure something out, fury rises up in them and the first thing that comes out is "I hate school!" I believe that is the reason why there is a negative attitude towards school.

— *Robert Carter*

HIGH SCH

ESTABLISHED IN 1898

Edith Garcia

Diego Cruz

Joseph Won

Our campus is ringed by a series of portables, portables containing broken windows, half-working air conditioning/heating, and crumbling ceilings. But it's not the school that counts, but the people who help to shape our lives. — **Jennifer Venhuzen**

Travis Finger

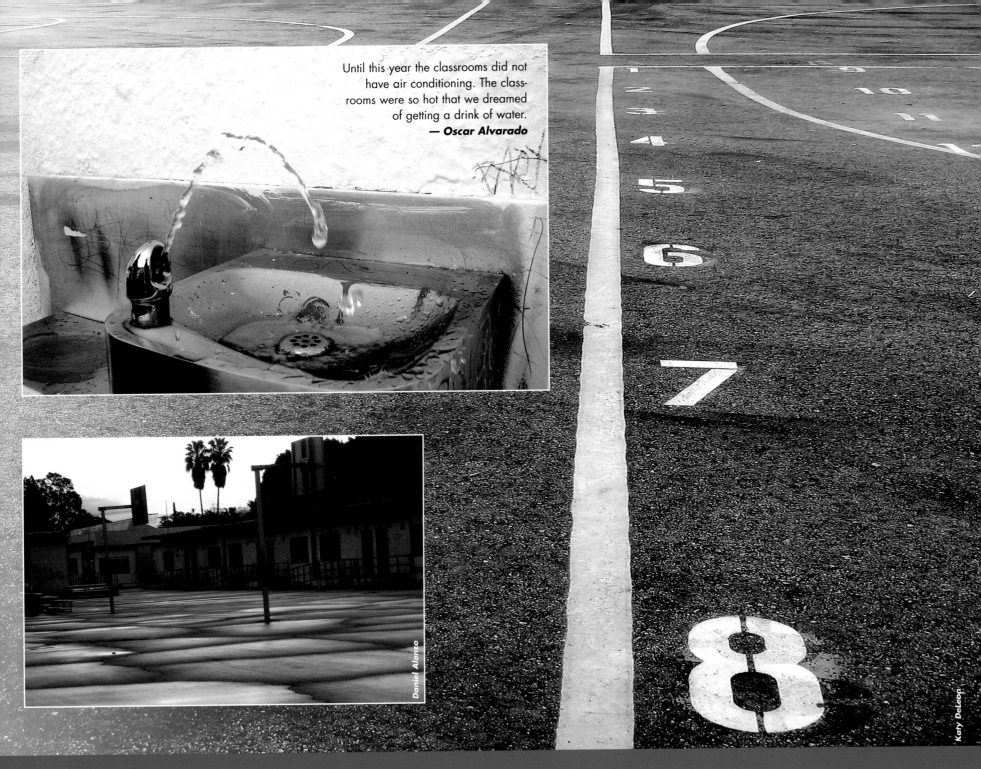

Until this year the classrooms did not have air conditioning. The classrooms were so hot that we dreamed of getting a drink of water.
— *Oscar Alvarado*

Daniel Alonzo

Katy DeLeon

technology in the schools

Some people might say that the advancement of technology is the best thing that could happen for this day and age. All around, one can see the forces behind the actions taken to include technology in our educational systems and in our workplace. It seems like a good idea when considering the benefits: tasks become easier, work gets done faster, everything is more accessible, and there is a wider range of knowledge at hand. However, if observations of a closer perspective are done, reality will display the mechanical mindset in which technology traps humans, and the everyday routine that technology imposes upon people. This results in our society's digression from knowledge.

Schools are filled with all the latest devices one needs to achieve a higher academic level, but kids today are growing up depending on such methods of succeeding rather than applying thinking to their lives. The world's computers, cameras, and calculators can't and shouldn't take the place of a child's imagination or way of thinking. Personally, I believe we have been worked like machines ready to spit out all the information the machines have input into our brains. All the homework being given to students requires reading data and regurgitating it back in the form of a speech, a presentation, or a test. This can be accomplished relatively quickly without taking the time to even understand what one is studying. It simply flows into the mind and flows right back out. We gradually become machines repeating the same process and going through life with

Anabelle Morones

a safety net over our eyes. There is no room left, and supposedly no need, to apply the human brain to think about doing the task at hand.

Although technology serves a purpose in accessing, acquiring, storing, and holding data, it's the human mind that gives meaning to that information. Human beings shouldn't be used in such a way because we're not built in that manner. We have to allow new ideas and space for change in order to prosper. Society can't just program students from a young age to work and act as robots. Learning shouldn't be reduced to a function that technology can provide. For my entire school life all I have seen is an endless series of projects, assignments, presentations, and so on. Most of my time has been spent in front of the computer or working

Background image by Jose Octavo

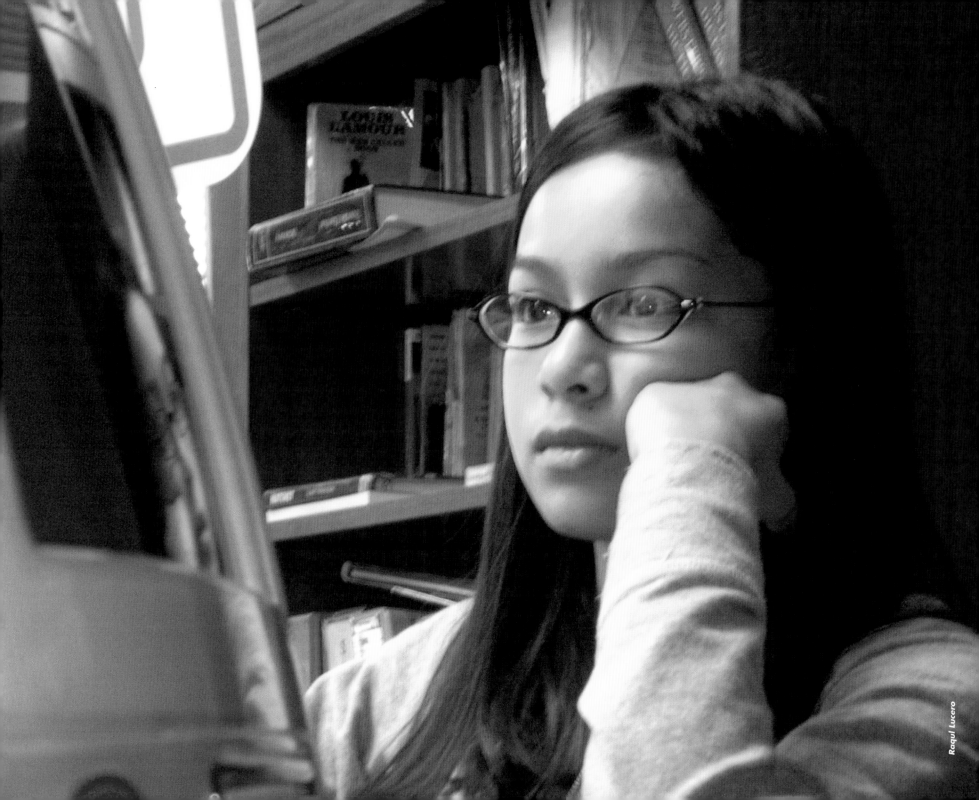

Raqui Lucero

A computer creates a very important bond between students and teachers. In class, we take quizzes in the cyber world. The day before the due date, every student studies for the chapter, and grabs a mouse to begin taking the quiz. The quiz scores are sent to our teacher in an e-mail, who records the student grade in his computer. Many students send an e-mail to ask the teacher a question and the teacher responds to their students with help and advice. Technology has entered our life. How can we imagine our school life without a computer?

— Na Hye Eunice Kim

Stephanie Ramirez

George Martinez

with cameras, projectors, and video cameras preparing for presentations. It's especially hard when the school you go to is a magnet school that has an emphasis on science and technology and which expects so much from every assignment you do. I never thought about the great deal of time it takes to perfect a simple video diary; all that editing that one has to do can drive a student crazy. Humanity was meant for more important tasks than merely working as a program in academics.

In this new century both students and employees depend immensely on technology and do not adequately employ the creativity and inventive part of the mind. Of course, technology can be used to fulfill its purpose of assisting the human race in our daily life, but if humans aren't included in the equation, eventually nothing will be able to function. For example, students can get the summaries of each chapter of a certain novel from Cliff notes or Sparknotes.com but the assignment won't be complete until one is required to analyze and reflect on the material. This is a major part of school life and what is expected from us.

We've been taught to work and study like machines to get ahead in life, but living things can't be treated as machines and produce work because our body and mind can't handle it. This seemingly obvious observation is often taken lightly which leads to the constant stress and depression that keeps millions of Americans spellbound. Technology is a thing to be appreciated, for without it, who knows how society would be reduced. On the other hand, technology wouldn't even exist without the great minds of inventors and scientists. When we learn to incorporate technology with strong thought processes only then will technology be used to its utmost potential.

— Ani Grigorian

Nakira Stepter

Background image by Eddie Jimenez

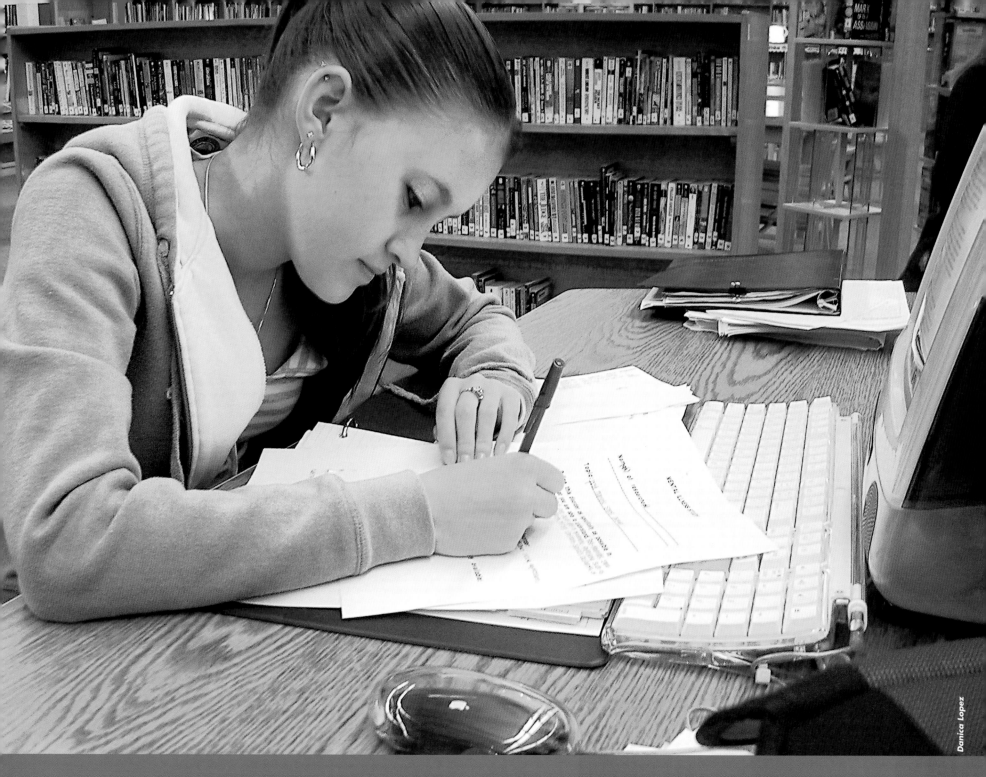

Danica Lopez

Technology has never been more evident in classrooms as it is now; there are computers in the rooms, laptops with the students, and even cameras for the teachers. Yet, despite the fact that technology was created to bring humanity closer together, might it have done the opposite? Are we so blinded by pixels and megabytes that we cannot even see the person next to us?

— **Andy Rivera**

Katy DeLeon

Craig Miller

Stefy Nudel

Library Carolina

Carolina Rosales

Background image by Daniela Martinez

The computers are lining up around the English classroom, leading to an important source of our education. We research the outside places where we can hardly reach. While collecting the pictures for the theme of the book, we easily find out the deeper meaning and symbolism of the book. The more advanced technology we use, the more advanced knowledge we get.

— *Na Hye Eunice Kim*

Y'Lan "Laney" Tran

Pamela Acosta

Bianca Williams

Jodi Hembree

Katie Bolson

Claudia Paz

Leyla Zacarias

Background image by Ashley Park

Certainly technology has made life easier, but its benefits are counter-balanced by its misfiring nature. Calling technology a godsend is pseudo-logic. For every time a gadget saves the day, another frustrates a user into submission.
— **Ruben Amiragov**

Carlos Ruiz

Carlos barahona

Susana Barrera

Ruben Amiragov

Luis Guzman

Marisol Perez

Andy Rivera

John Sugimoto

Brianna Cendejas

Then there are the kids who strap on about a dozen devices such as mp3 players, graphing calculators, portable TVs, CD players, and radios and walk around school while using all of them at the same time. If you look anywhere at school, you can see these students who seem tech savvy and look like cyborgs with 10 pounds of electronic gear strapped to them. It's hard to even talk to these people. You try to say something and if they even hear you over their loud music and calculator games then they will tell you to get lost. — *Serozh Sarkisyan*

Don't bother me, I'm computing.
— *Carlos Ruiz*

Victoria McDonald

Ty Albro

Left: This is a photo of a friend of mine, Ty. My teacher told us to empty out any technology that we had in our backpacks or in our pockets. As a class we were able to make a big pile of cell phones, game boys, calculators, and CD players. It seems that everyone at school has some sort of technology on them. Some people had odd pieces of technology in their backpacks like a coffee grinder for Foods class, and an alpha smart for English. Technology advances have changed the way school is taught and has changed the way students learn.
— *JJ Fairbanks*

"To be or not to be that is the question." In my Language Arts class we are watching a film on *Hamlet*, a very popular Shakespeare play. Instead of using an individual book to teach the students my teacher decides to show the movie through the technology of a projector. Technology is advancing every day. 100 years ago they were using chalkboards and pencils. Pretty soon we will be using holograms and microchips to earn a grade in class.
— *Jon Sugimoto*

So even though we're entering the 21st century (a.k.a. The Century of Advancements), school has barely changed since the last century.
— **Eric Henrique**

Hanna Crosby

Jaimie Thai

Lindsey Kearney

Josh Torrez

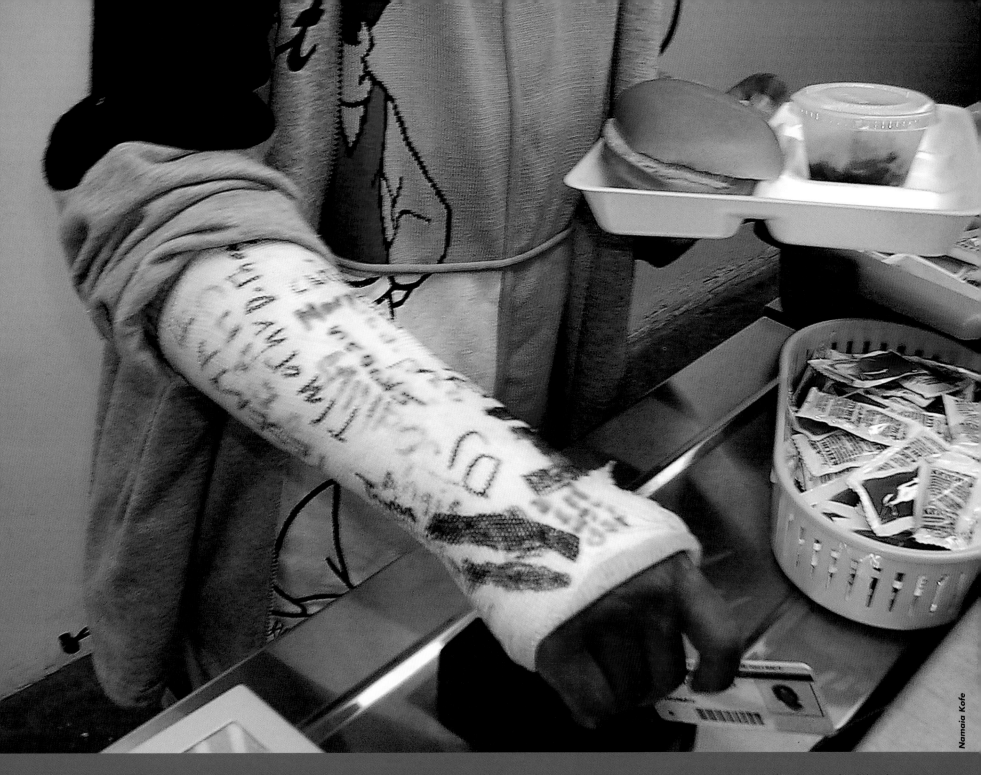

Namaia Kofe

One of my friends asked for my cell phone number. As soon as that person said that, some of my other friends around me took out their cells to do the same.
— *Tony Reyes*

— Caitlin Bellah

Students were either talking on the phone or waiting to start text messaging again. Where she held a planner and a pencil, others held iPods and cell phones.

What a sneaky girl. She is talking on her cell phone when she is not supposed to! Cell phones are not allowed on the campus, and she is trying to talk with her friend. She has to hurry, because if the teacher catches her, she will get after-school detention.

— Diana Matus

Yekaterina Novikova

As she walked through the group, she heard a familiar song blaring from some headphones and at least half a dozen phones ringing. What struck her as odd was that no one even thought anything of it. No one found it disturbing that in a learning environment there were so many distractions. The sad part was, the teachers had no clue that it was happening behind their backs.

— *Caitlin Bellah*

Rebekah Oliver

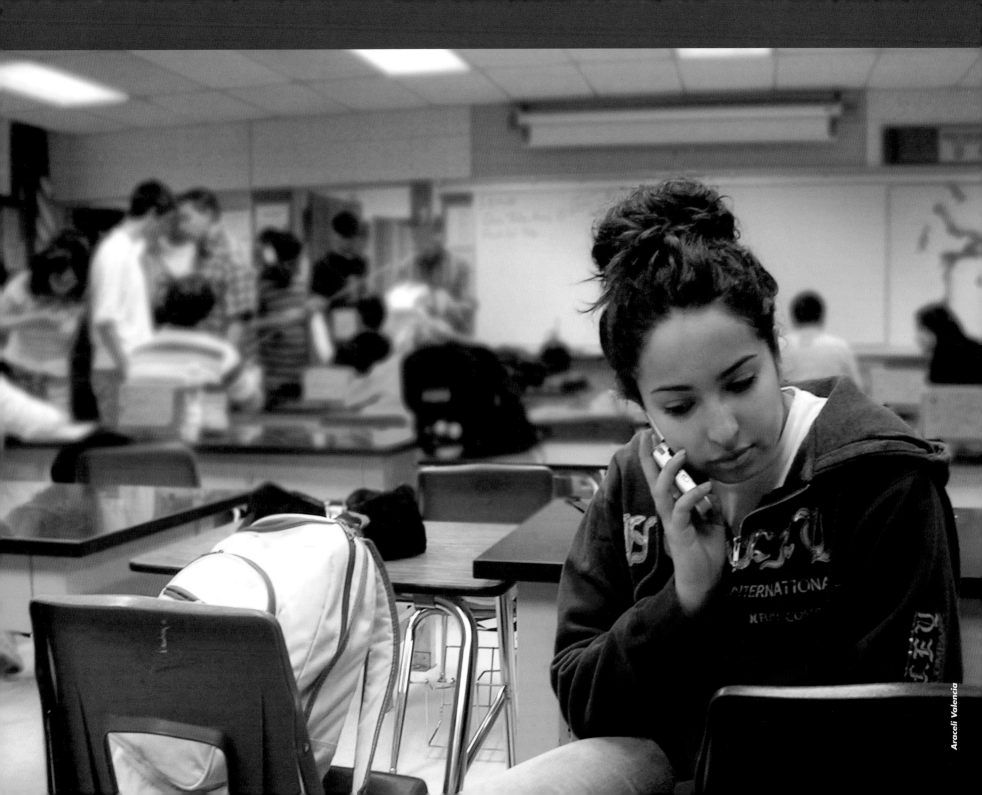

Araceli Valencia

The music leads to another place where problems don't exist and you feel as if you're reborn and reenergized. I exhale deeply, letting the stress from the day bleed out of my ears through my headphones. Out of nowhere, a loud bell appears and my eyes pop open. The reality of responsibility, school, and life comes crashing down upon me. The steel chains are reattached as I pick up the iPod and put it back into my backpack.

— **Ryan Mak**

iPod, the device that has swarmed the teenage world, has taken over. The small white Mp3 players have rendered CD players somewhat obsolete. Almost a month ago, one of my friends received a demo CD from a band. He had an iPod, so it was impossible to listen to it at school. He wandered around campus and asked roughly twenty people if they had a CD player. There wasn't one. A smattering of mini-discs, other Mp3 players and tons of iPods. It was a rather amusing sight. — **Lauren Ward**

Elise Frontino

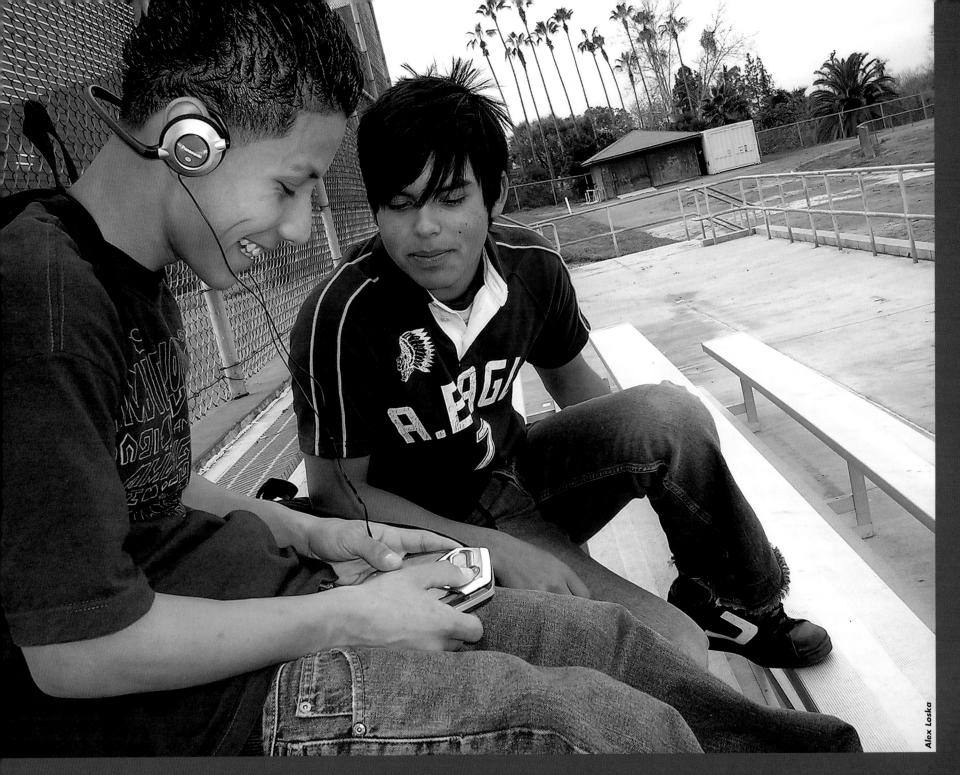

Alex Loska

If you are a high school teenager, you think of a cool new way of learning. Teachers at our school are always integrating technology into their lessons to give kids hands-on experiences. I think if all of the teachers used technology, more kids would want to learn. — **Sonica Patel**

Background image by Kevin Ramirez

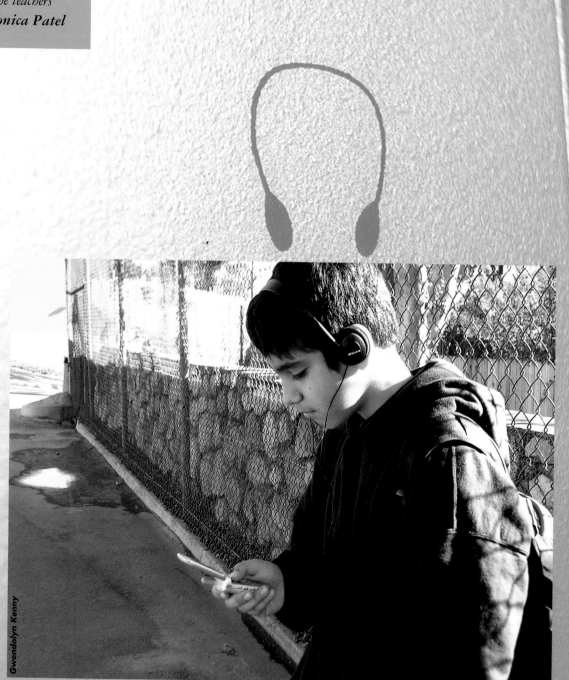

Gwendolyn Kenny

It's funny how the eye was made by God in the beginning of time and is still more technologically advanced than this CD, or just about anything else ever made. — *Daniel Koval*

This "technology" is out of date, poorly made and easily broken. The computers that we have are slow and lack memory. It took me about five attempts and two weeks to load the photographs to the FirstClass server. The computers we use crash more often than bumper cars. I'm almost certain that my calculator has more memory than the computers at my school.
— **Zachary Clayton**

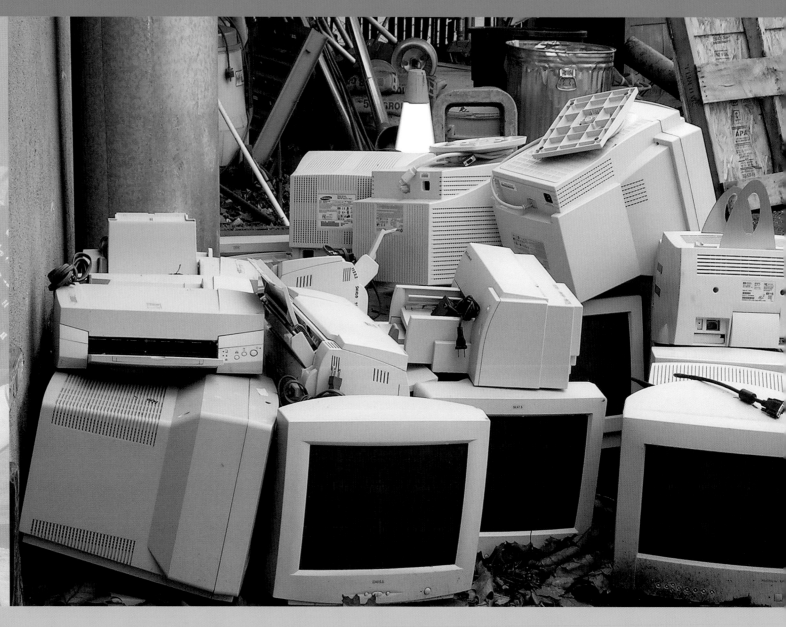

Background image by Gloria Nuila

These computers have lost their touch and it was time for a new batch. Thankfully the budget cuts in California have yet to get to this part of our state. We are thankful for a change and thankful for the luxury to get new computers. When a computer looses its soul or gets eaten alive by viruses, it has had enough and they are replaced by the new and improved technology.
— **Stephanie Milz**

Amber M.

thoughts, feelings, and beliefs about school

Everyone wonders if they are alone at times. It's normal isn't it? Sometimes the pressures of life simply become too much to take.

This feeling is not just the dread of the student body of any school, but the common reaction when good luck runs low, and bad luck runs high. This feeling eats at you slowly, and, as a near-sighted juvenile, all you see is never-ending pain, and you know that it will never really change.

Fortunately, the world is not as small as we see it when we are 16. Girlfriends or boyfriends come and go, and in the long run, the answer to number seven is not life changing. Eventually, we will all move on. We will graduate and go to college. At college, children become adults, and realize the futility of their worries in the previous levels of education. What adults do in college though, is worth all of the frets and worries in the world.

Only it won't end there either. When adults become parents with jobs, their focus shifts once more. After all, how important is college when compared to the harsh realities of the real world? Of course it seemed important then, but now you see. Now you understand what is truly important.

Didn't a famous man once say, "the unexamined life is a life not lived"? The adults, of course, never examine their life. They have lived life so they are immune from the ignorance that comes from not examining the world in which they live. Nothing is or ever will be more important than the jobs that they hold so dear. In fact,

Henna Patel

they are so worried about their own divinely important purpose, that they do not simply ignore the plight of the children they once were, they scoff at it.

Their children still, however, see the story from their end of the tunnel. Certainly the parents only wish to help the next generation realize what is truly important. Didn't another famous man say "what good is the blind leading the blind?"

Who sees all then? If neither the parent nor the child can see, who is there to justify a position of leadership? There is one simple answer. No one. The divine purpose of the parents are in turn infantilized by the elderly, who believe only death takes precedence, and they,

Background image by Isidro Meneses

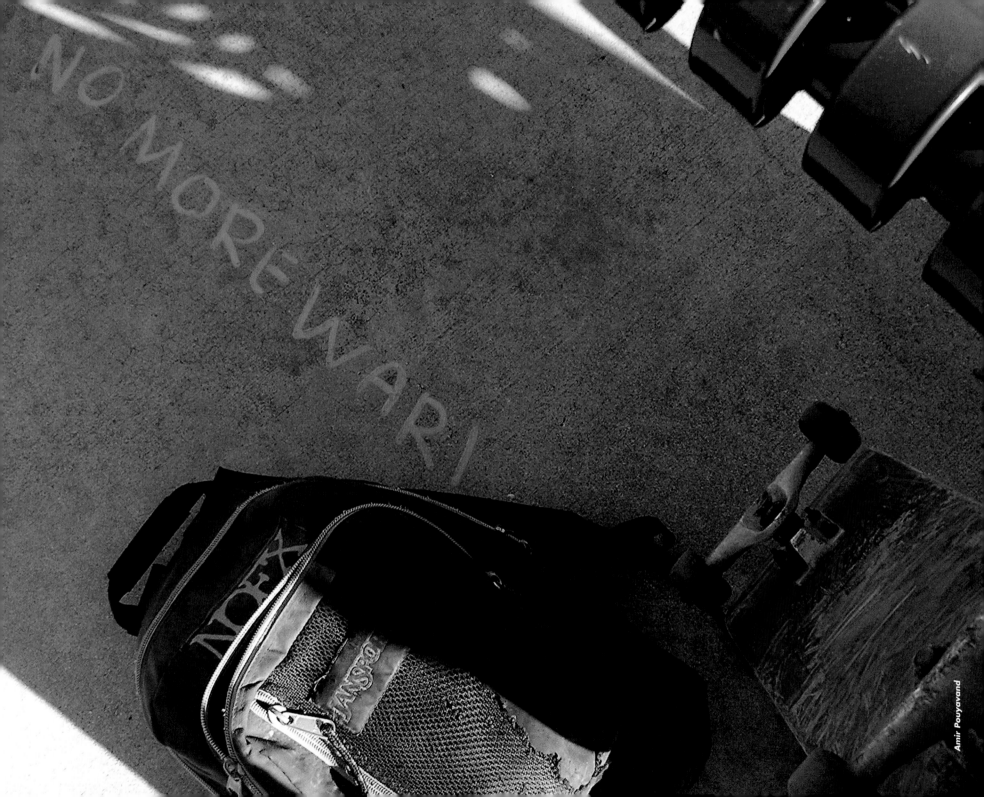

NO MORE WAR!

NOFX
JANSPO

Amir Pouyavand

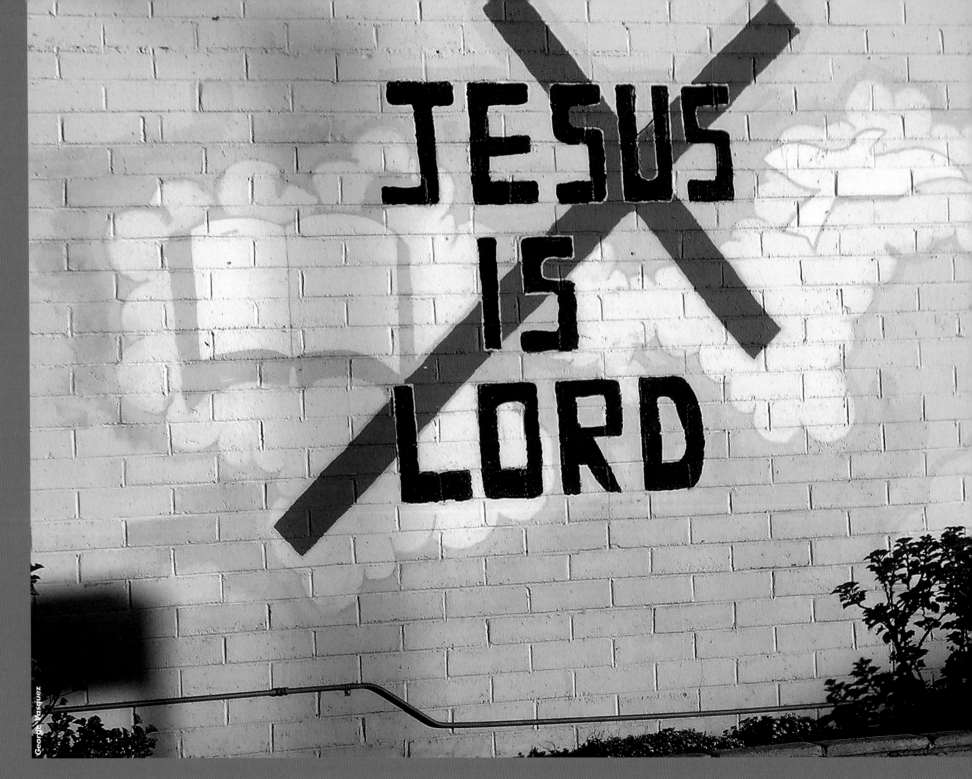

Jesus is Lord

George Vasquez

in their own right, are ridiculed by the dead who feel all by feeling nothing.

No one truly understands the plight of another person, because they can never know all of the variables. Every problem is justified in the mind of the recipient. The most we can do is this: Do not disregard the problems of others, no matter how stupid, irrelevant, or idiotic it might seem.

High school life. College life. Life is blunt and empty. We may not see things immediately, but one fact remains! The only thing we are given in this life is our mind and our eyes. Know what you can, see what you may, accept the rest, and the world is yours

— *Andy Rivera*

Megan Fiske

Beliefs toward school are a cornucopia of teenage anxiety, youthful rebellion, anger, love, confusion, distortion, oppression, fear, re-birth, expression, discovery and demise. The transition from child to adult rips through the nervous system, skewing the senses; ideas are conceived only to be revised because of either internal or external forces. Minds clash in beneficial struggles.
— **Ruben Amiragov**

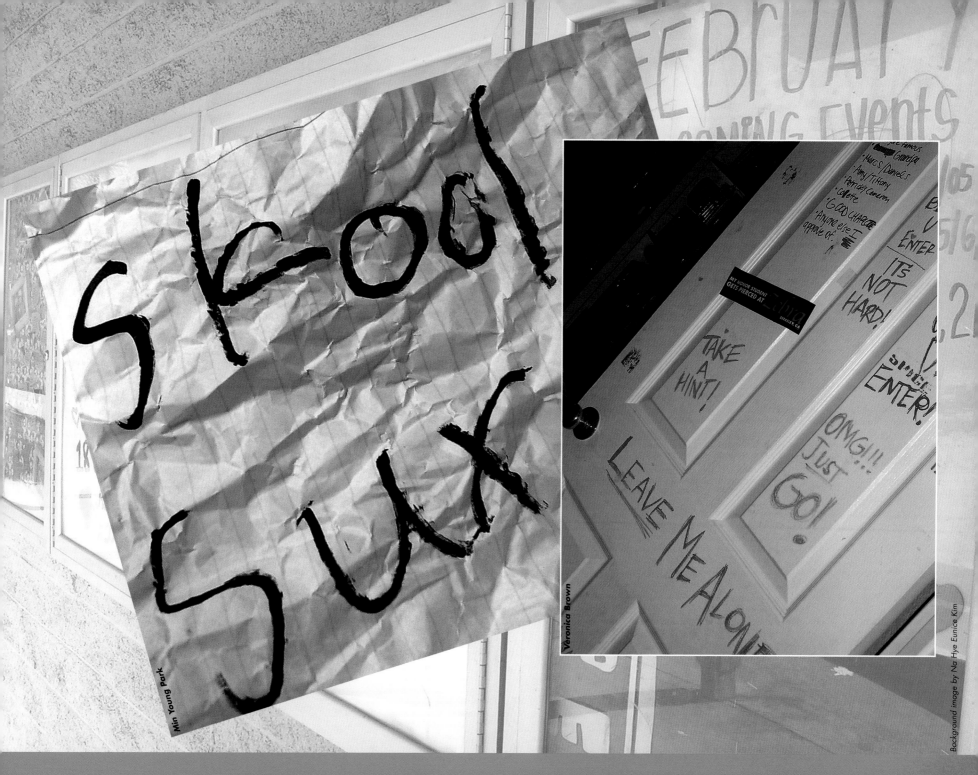

Min Young Park

Veronica Brown

Background image by Na Hye Eunice Kim

The different types of shoes represent the different ethnicities of students. Nowadays whether you're Caucasian, African American, Mexican, Chinese, or anything else, it doesn't matter. Everyone can come together and hang out no matter what race you are. Different shoes—different people. We all are unique at school in a different way! — **Jessica Price**

Jessica Price

Chris Graham

Tiffany Carnes

Candice Oliver

Elle Leung

Donovan Mckelvey

Laikeya Patton

Heidi Almberg

You can tell a lot about someone from their shoes.
In a world ruled by a dress code, shoes help us
express our individuality. — *Alina Barron*

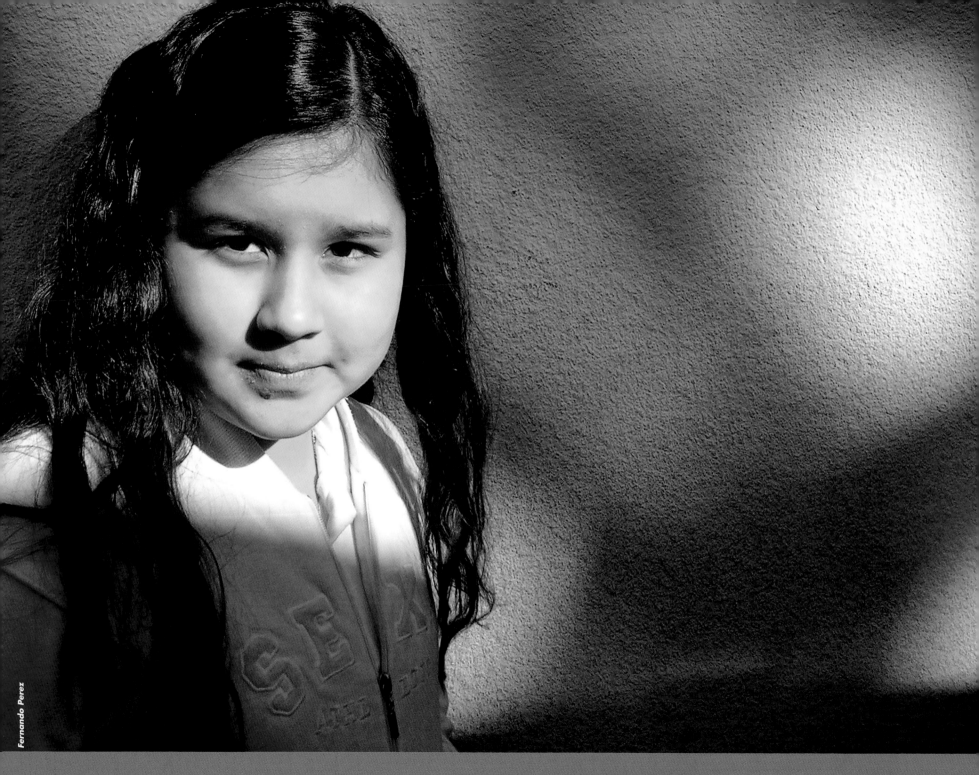

Fernando Perez

En los ojos. *In her eyes is hope. We are the hope of our families.*
— **Fernando Perez**

Jessenia Banegas

VIOLENCE PREVENTABLE

OT HEALTHY PEOPLE

TOP IT

TALK

Background image by Daniel Alonzo

If all of us keep an open mind, we could really have an amazing school where we all put our differences aside, learn from each other, and leave high school with a better knowledge of different cultures so that we will not judge others. — **Kristina Young**

Soleil Garcia

A teen's life revolves around music and to make your own music at school is a great gift. Most teens just eat or talk during their breaks but these kids make music for other people to enjoy listening to. I believe that music helps students get through a lot of their problems. Music is like the gateway to another place where nothing can touch or bother you. — **A. Chavez**

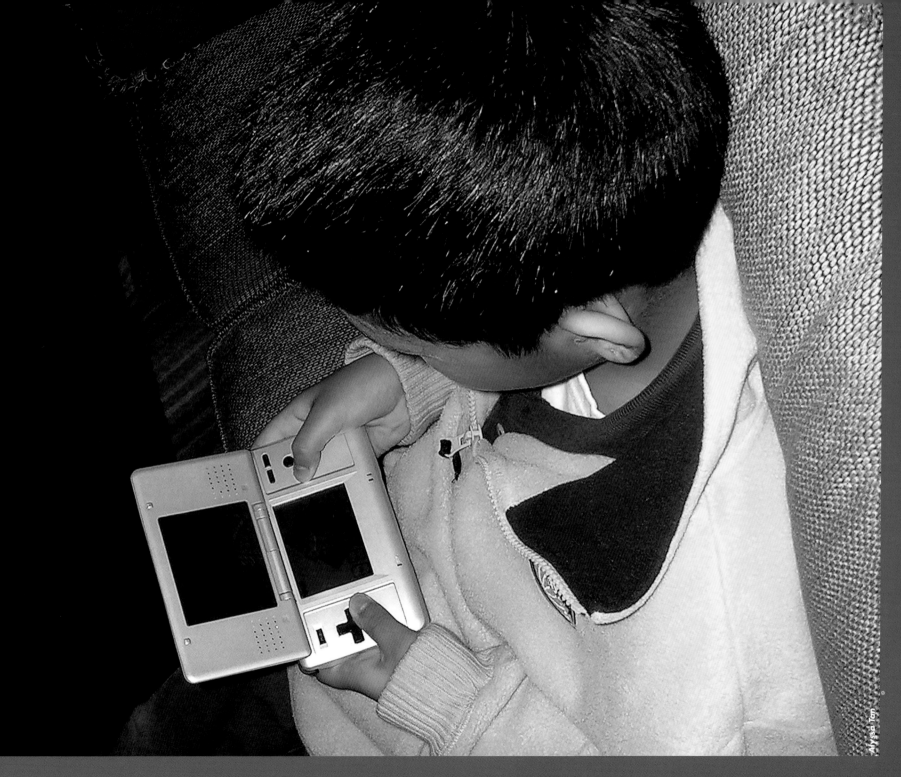

Alyssa Tom

The reflection of a soul trapped underneath shattered mistakes. We can see through the cracks of our self-imposed emotional prison, yet we can't reach out for life.
— **Sonia Vargas**

Background image by Chris Mason

Daria Rycewicz

Michael Preston

Jesus R.

Pedro R.

Some strive for the best and with strong determination and victory they triumph over all the odds; others weaken and break under the pressure, only to be left behind.
 — **Ani Grigorian**

Sally Samtoyo

Background image by Johanna Hu

Students in classrooms are falling asleep during classwork, essays, projects, and just plain old work. This keeps happening to our school because our time for the school to get to the first class is at 7:44, which is pretty early for some students. Most students don't live near the school. They live like approximately 30 mins. to 1 hr. away from school. I'm always tired because I take the bus to school, and it picks me up at 6:07. So I have to wake up at 5:30 and do my daily routine before the bus gets here. So I don't get that much sleep.
 — **Adam Jacomb**

Adam Jacomb

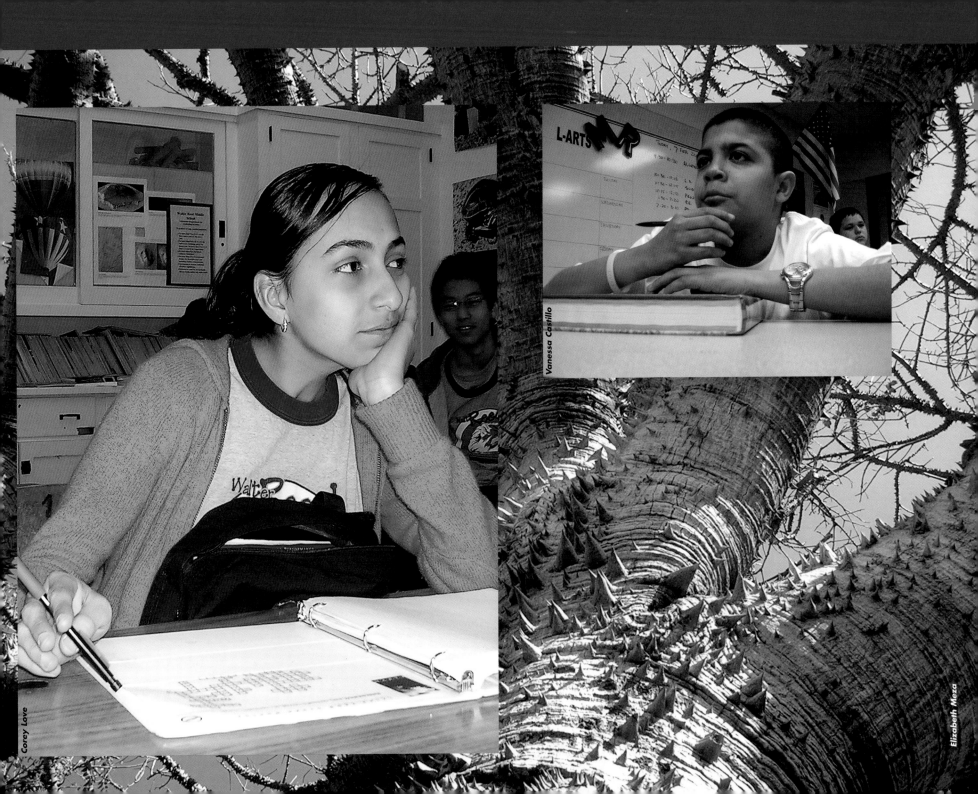

Corey Love

Vanessa Castillo

Elizabeth Meza

I hate this class. I'm sick of those stupid warm-ups called "PACOS".
I'm sick of taking notes in the "apuntes" section of my notebook, and I
am sick of recording everything in my stupid agenda!
— **Danielle Lemi**

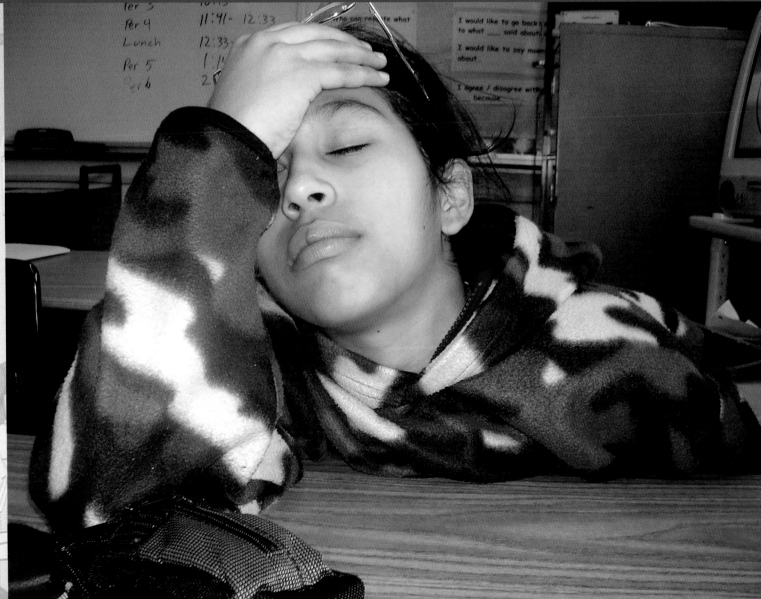

READING MAKES LIFE A LOT EASIER

This is a picture of a bored girl in class. She is so bored she looks like she is about to fall asleep. I chose this picture because it is a good representation about how most children feel about being in class. Even though it's of kids feeling bored, there are also some who feel the exact opposite.
— **Garret Rouleau**

Background image by Michelle Samson

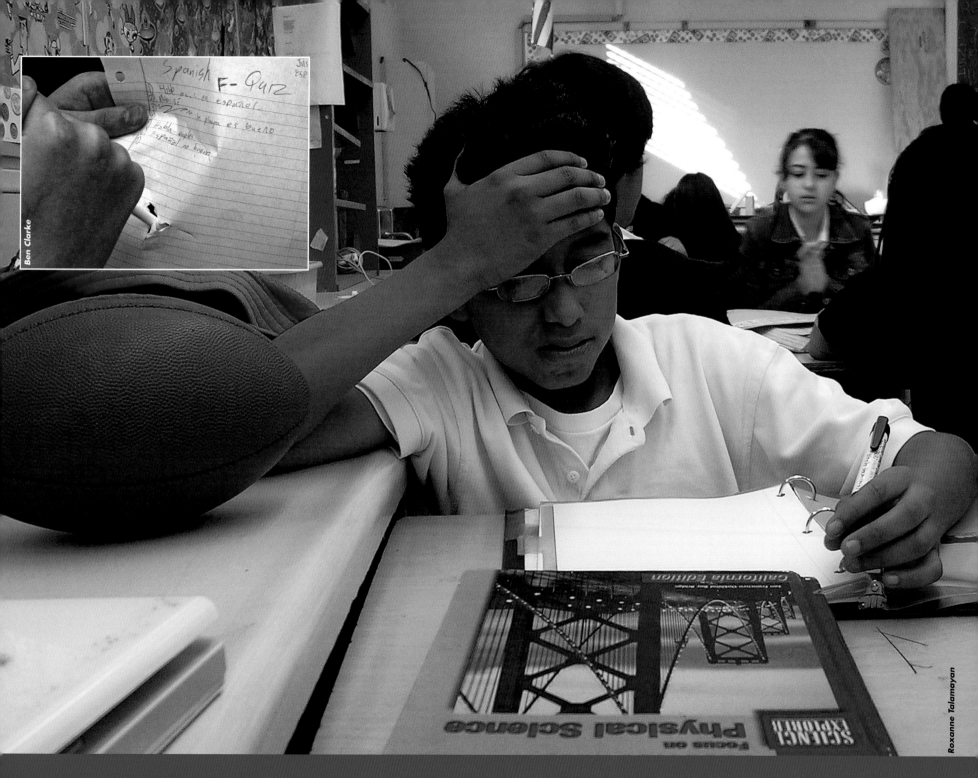

Ben Clarke

Roxanne Talamayan

Now I see the loneliness that has surrounded me. My innocence and childhood are gone like common sense from today's teenagers. The evil that corrupts society becomes more and more evident the older I get. I still think back to when I was young. I want to go back to that playground. I want to get the sand in my shoes. I want to slide so fast that the world can't even see me. I yearn to swing and feel that moment again. The wind would be blowing through my hair, and I would be filled with the ecstasy of flight. I can almost touch the sky…

— Katie Pelfrey

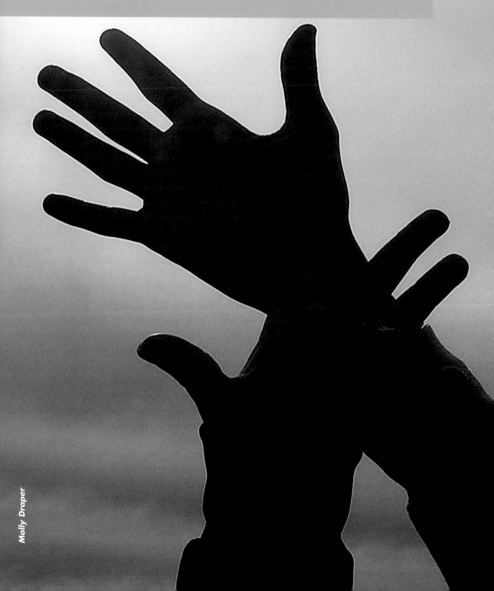

Molly Draper

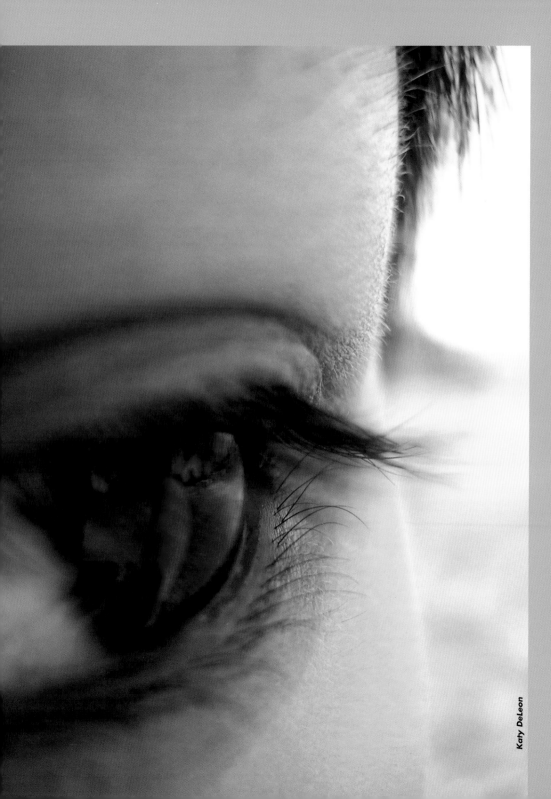

Katy DeLeon

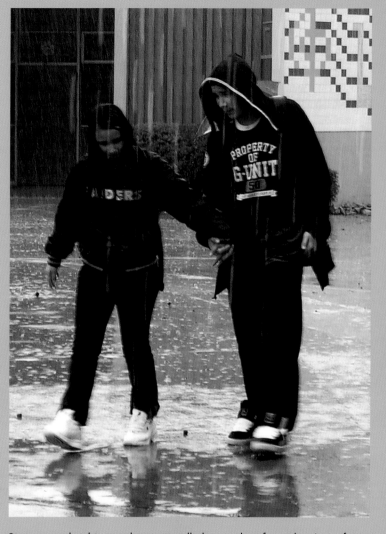

Since our school is co-ed we naturally have a lot of couples. Lots of student's learning experience is distracted by the opposite sex. I think personally that having someone you like romantically gives you someone to think about during your boring classes. It gives students something to daydream about and it is hard at times to stay on task. Couples also give the other students something to talk about. Other students love to gossip and discuss everyone else's relationships. I would say romantic relationships are a huge part of high school today.

— **Kaitlyn Urrutia**

My biggest fear is that I will grow up and not become anything. I want to have a nice family, nice house, a wonderful job, and wake up smiling every morning. I want to change lives, and make a difference, even if it's in a very minute way. I don't want to be a nobody.

— Margot Magistrali

This photograph says a lot about the love that we cherish among our students, staff, and teachers. Recently our security guard, who really kept our school safe, retired. This photograph captures the memories of our fellow staff departing.

— Joseph Won

Background image by Ani Akopyan

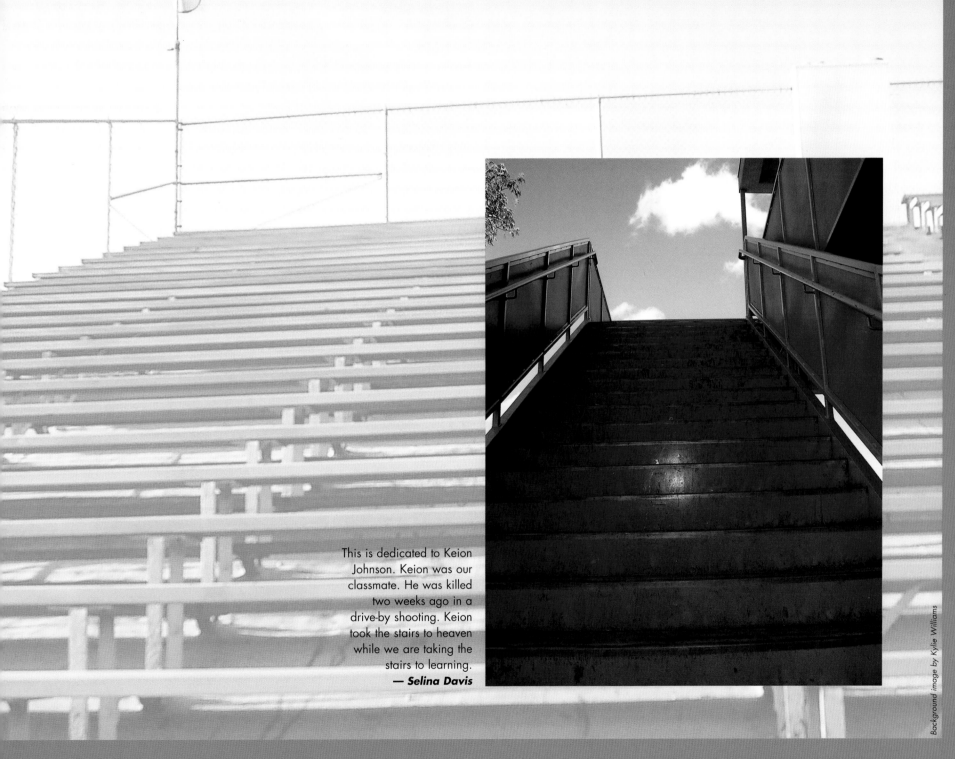

This is dedicated to Keion Johnson. Keion was our classmate. He was killed two weeks ago in a drive-by shooting. Keion took the stairs to heaven while we are taking the stairs to learning.
— **Selina Davis**

Background image by Kylie Williams

Although textbooks may be designed to offer insight into answers and facts, one is only left with more uncertainties and ponderings that have yet to be answered. It's ingenious how high school coincides with the coming of age that we must all experience, and although the road ahead may look hazy, one can be sure that there is something beyond the end of that looking glass.

—**Jae Park**

John Che

Eddie Jimenez

William Lee

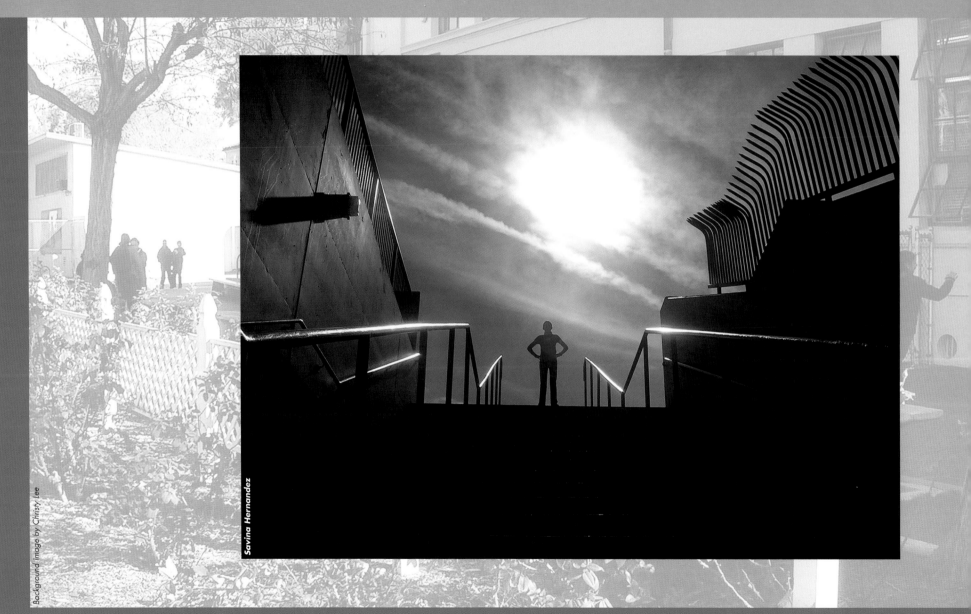

Background image by Christy Lee

Savina Hernandez

This picture shows how the pressures of Phoenix Academy can sometimes drive you "out on a limb." At some points we can feel so overwhelmed by all of the work we must do to improve our lives, that it seems there is nowhere to turn. Fortunately, we have many people here to help us get over these troubled times and help lead us to more stable landings. In the end, we always find our way out of the storm and onto solid ground again.

— *Michael J.*

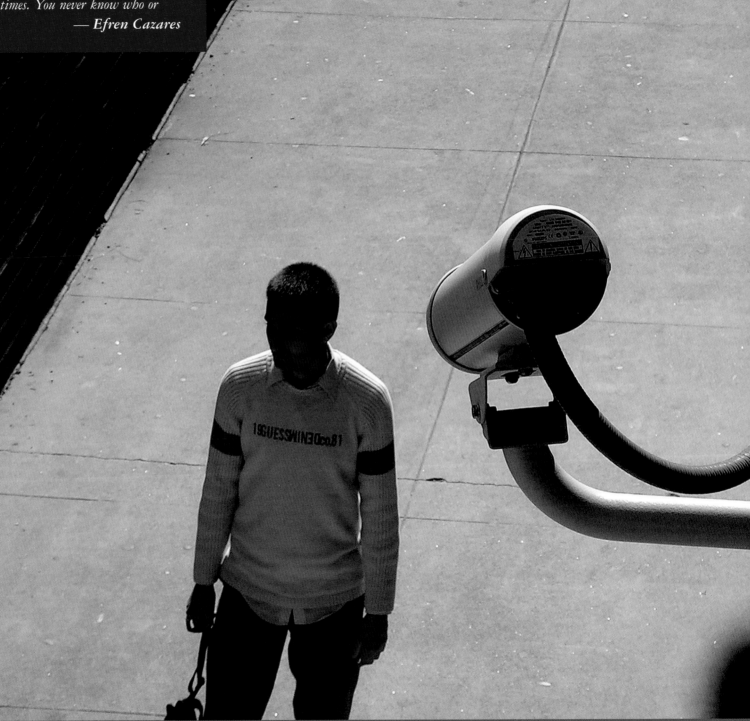

There are people watching you at all times. You never know who or when they are following you.
— **Efren Cazares**

Schools are surrounded with surveillance cameras. One may argue that the use of cameras invades people's privacy and that it is much like Big Brother watching us in school. It also shows that there isn't much trust in the students since their behavior is closely monitored at every corner. In my opinion cameras are very advantageous because they serve their purpose. They can give justice whenever a rule is broken and can prove things that disturb the school. It is something that we have to live with because we do not live in a perfect world. The help of cameras makes school a reassuring and safer place to spend half of our day in.
— **Zaruhi Galstian**

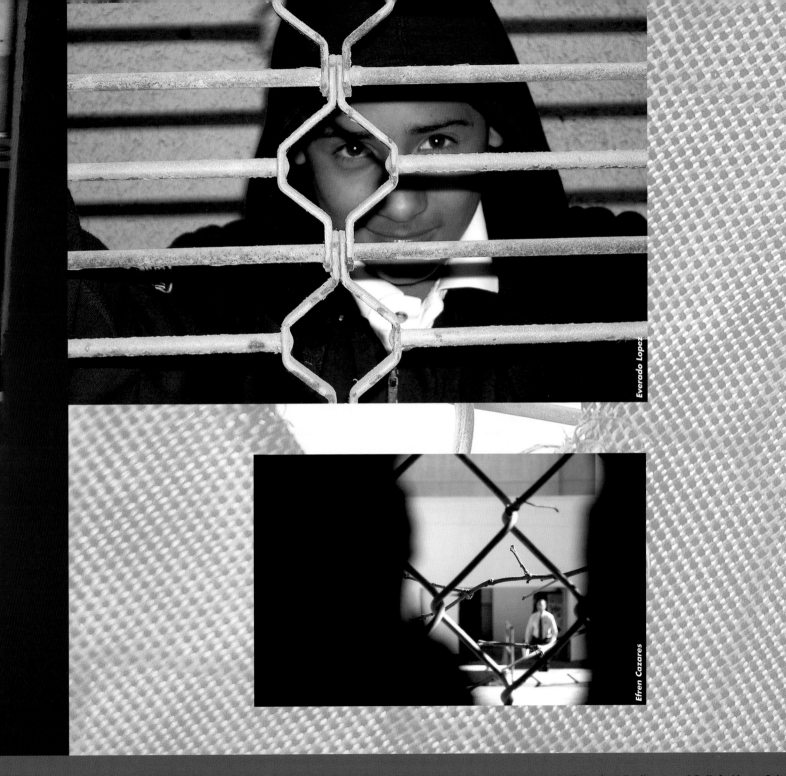

Everado Lopez

Efren Cazares

Background image by Luis Orenos

Our home is encased by a metal fence. Trapped here from our own free will, yet we choose to be here. The lives we thought we had under control seem to become more and more chaotic. We live day by day in these gates surrounded with other kids who have the same backgrounds and issues - lost from civilization struggling to get back on our feet.

— **Manuel L.**

This photograph shows one of many of the kids at my high school trying to be free. One hundred years ago, there was never any fences locking the kids in, or anything like that. Now, you never drive by a school without seeing some type of fence holding the children in. It is like a prison for us kids until the bell rings for the day to be over. I couldn't count how many times I looked outside of my classroom and felt like I was locked up. This is a free country. Yet for some reason, I still do not feel free!

— **Elizabeth Dagit**

Background image by Luis Orenos

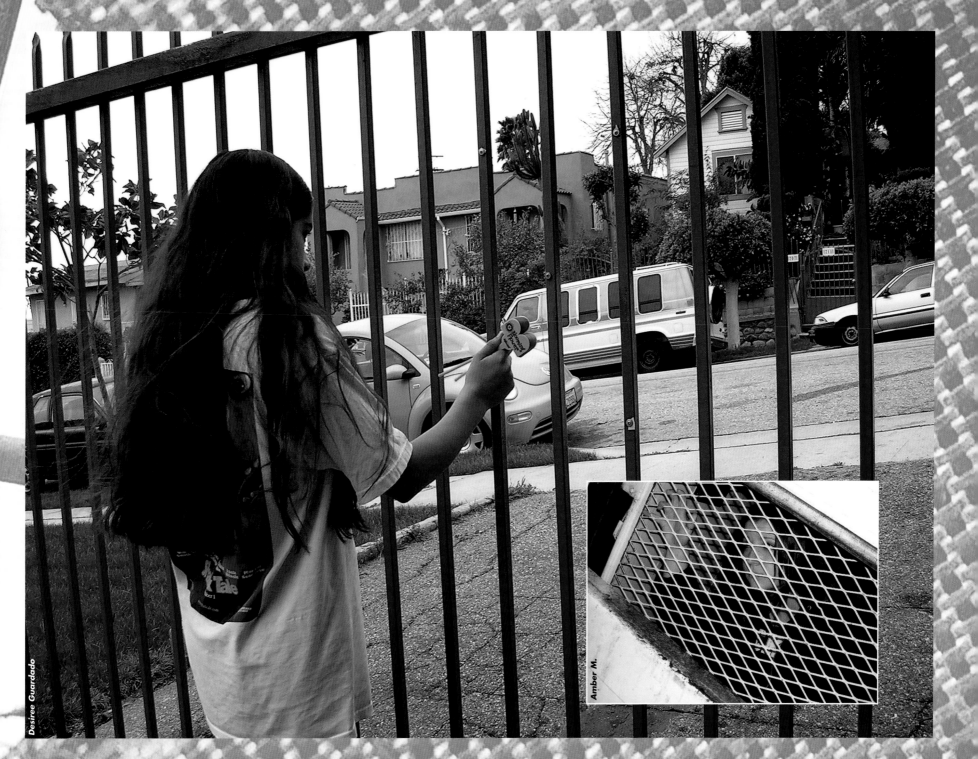

Desiree Guardado

Amber M.

Most people think that only poor kids or gang members end up out on the streets. Actually even wealthy families with everything going for them can fall apart. Most teenagers have issues, but it is what they choose to do about them that counts. I have heard many tragic stories about kids who missed an opportunity to take the best path. There are many regrets, yet chances still remain. — **Pedro R.**

Bianca Marte

Amber M.

Background image by Pedro R.

Amber M.

how students play

All through school I have competed in sports. Whether it was playing basketball at lunch or playing on Sonora High School's football team, I have always been involved in athletic competition. Many things have changed over the years I have been in school, but many things have remained constant. For instance, I have never been, nor will I ever be, an outstanding athlete. I like to try everything but I don't necessarily excel at all of the activities I try. One thing that has stayed the same is how sports are viewed in the school system. In every organized school sport I have played, there is one ground rule that is always recognized: Playing sports is a privilege, not a right. Once I entered junior high, I really began to reflect on that statement. And now that junior high has long since passed, I have come to the conclusion that, for me at least, that statement is incorrect. Sports are a necessity.

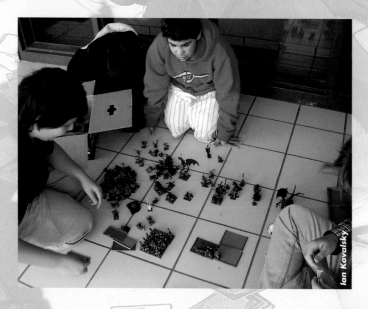

Ian Kovalsky

All my life I have strived to earn perfect grades. Academics, unlike athletics, come relatively easy to me regardless of the subject. In seventh grade I received all A's and in eighth grade I earned above a 4.0 G.P.A. In spite of this, when I learned that all athletes must earn at least a 2.0 G.P.A. to be eligible to compete in school sports I got scared. I was afraid that my grades were going to get in the way of being allowed to play sports in school. So, from fifth grade on I dedicated myself to making sure my grades would never affect my eligibility. Little did I know that this decision was going to be one of the best choices I had ever made. Since then I have never earned a G.P.A below a 3.4.

Based on my academic record, it is obvious that grades have never actually been a problem for me, but grades have been a problem for others. For instance, the issue of being ineligible to play on a school team really hit close to home in seventh grade. It was right before the championship basketball game against our big rival, Curtis Creek. We had been preparing for this game for weeks. Our minds were solely focused on how we could beat them. Two weeks before the game, much to the team's dismay, grade reports were sent out. Our team took a big hit. We lost our starting point guard because he had an F. Now, imagine if this grade report came out during the off-season. Obviously this boy did not care about his grades very much, so he most likely would not have done anything about his F. Becoming ineligible during basketball season was different. This F meant our team would be without our best point guard for the big game. Immediately the boy started hitting the books. For two solid weeks he stayed indoors after

Background image by Dro Amirian

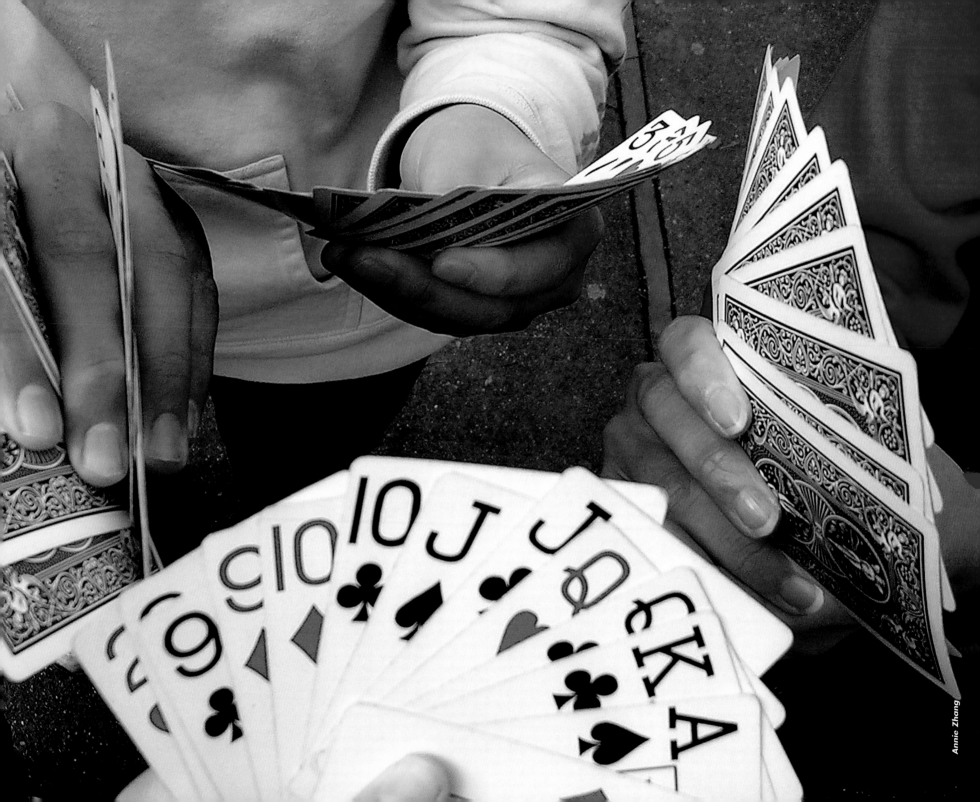

Annie Zhang

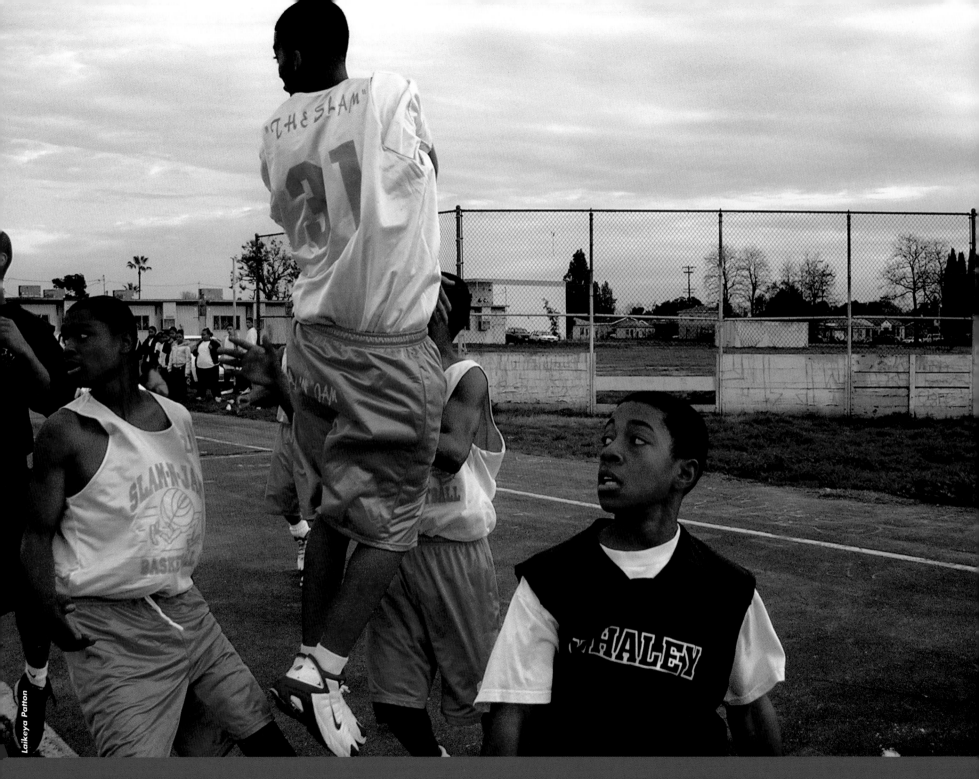

Laikeya Patton

Lena Saleh

Linda Nguyen

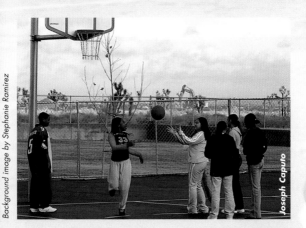

Joseph Caputo

Background image by Stephanie Ramirez

school trying to bring his grades up. The idea of not being able to play in the game was unbearable. So unbearable that he decided to do whatever he had to do to get back on the court. Game day arrived and so did our point guard. He brought his F up to a C, making him eligible to play. He ended up making the winning free throw to beat Curtis Creek 45 to 44.

Sports are a privilege not a right. That is what I have been told to believe for years. Because of the stories like the one about my seventh grade teammate, I will never agree with that statement. If sports were taken away, then the motivation for many people to do well in school would be eliminated as well. If it were possible, I know that many kids would just want to play sports and not go to school at all. Luckily, it doesn't work that way. And because of this, kids try hard to earn decent grades so they can do what they love most. Sports are more than a source of fun, they help kids succeed in school, one game at a time.

— *Robert Carter*

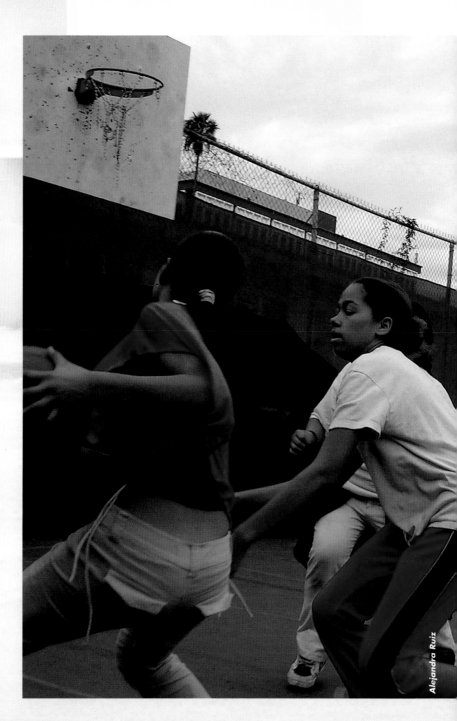

Alejandra Ruiz

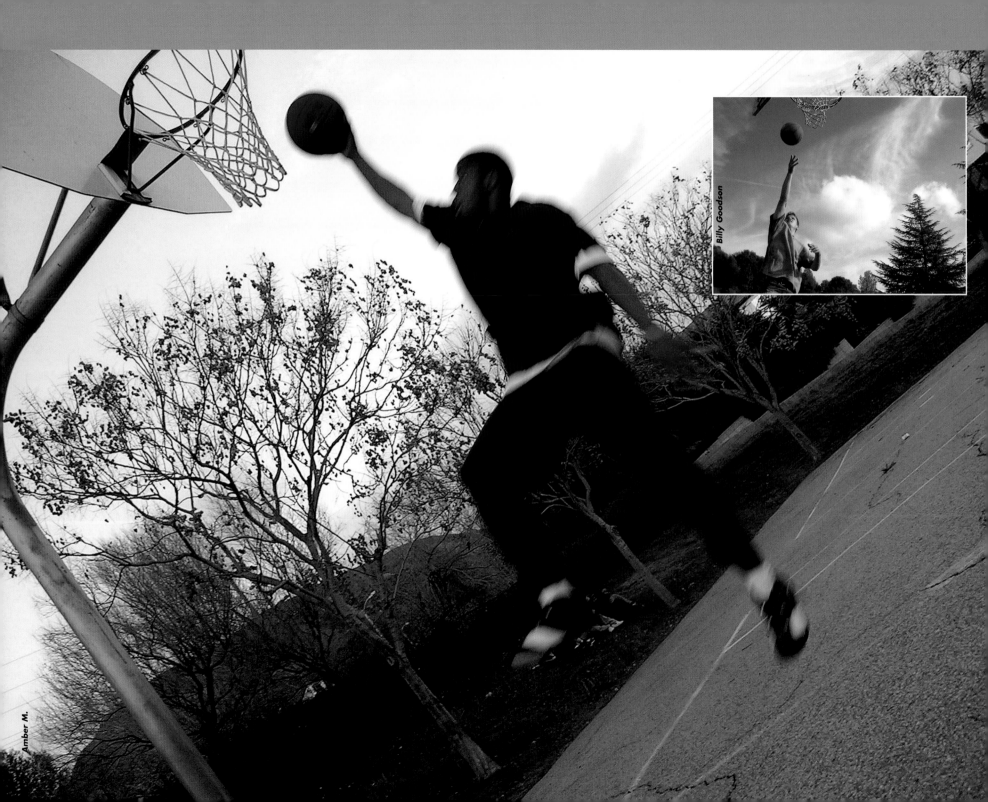

Amber M.

Billy Goodson

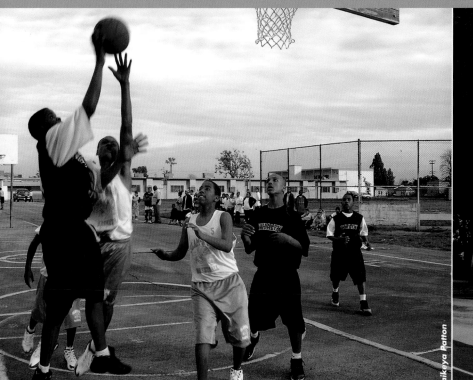

Laikeya Patton

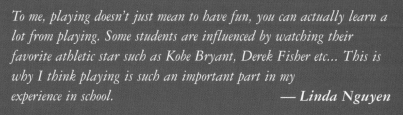

To me, playing doesn't just mean to have fun, you can actually learn a lot from playing. Some students are influenced by watching their favorite athletic star such as Kobe Bryant, Derek Fisher etc... This is why I think playing is such an important part in my experience in school.
— *Linda Nguyen*

Christopher Mineros

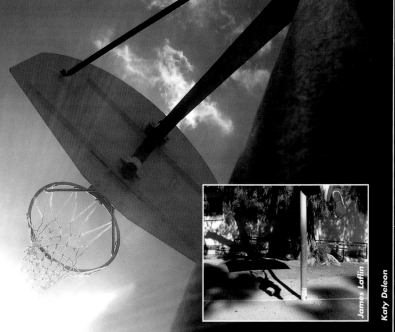

James Loflin

Katy Deleon

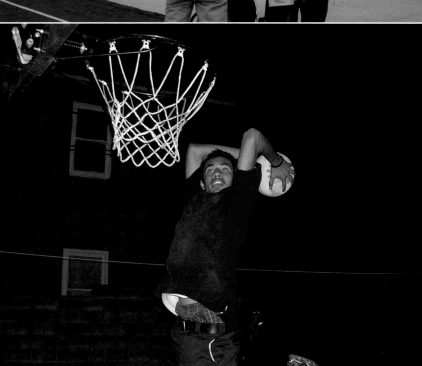

Gordon Zhou

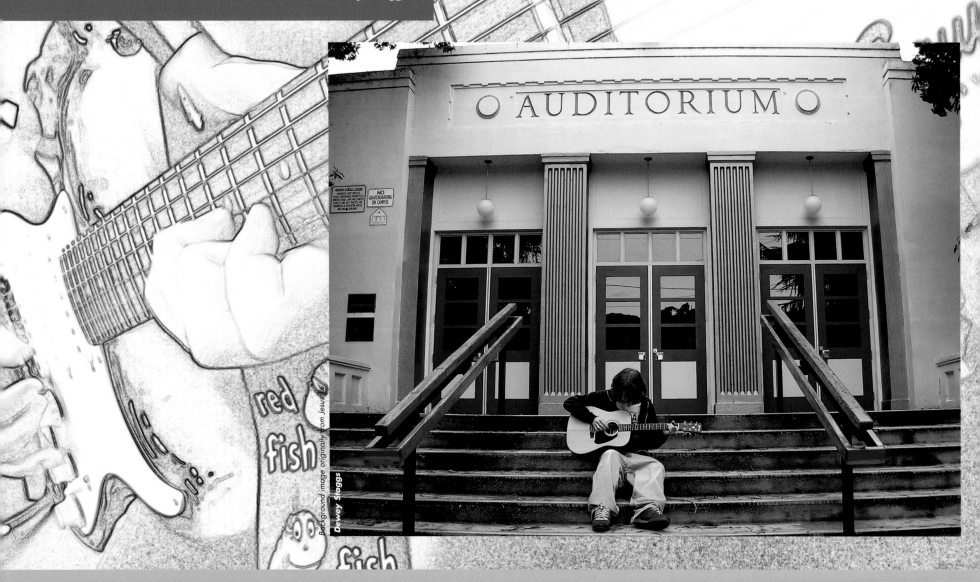

The high school musical program allows students to challenge them-selves and to express their creativity. Many students also play their instruments at lunch which brings entertainment to others. Without music here at Sonora, school would be a lot less interesting and diverse. Fortunately, the school realizes the need for music programs and offers many different types of classes for the musically gifted while still appealing to the many interests and styles of all students.

— *Dewey Staggs*

Background image originally from Jesus

Dewey Staggs

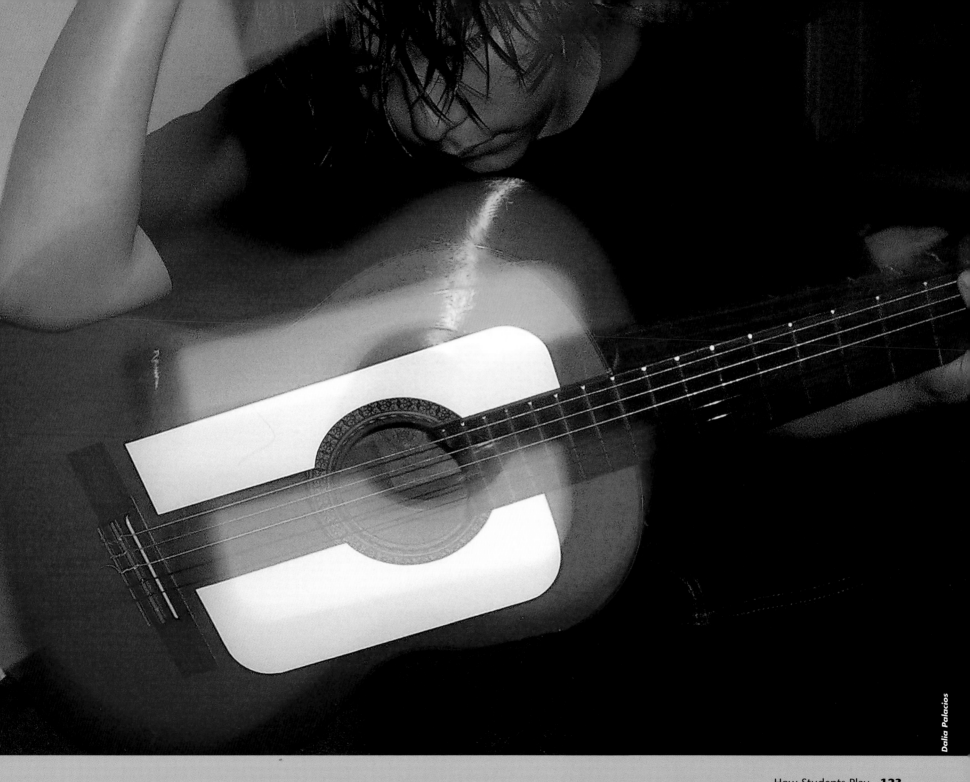

Dalia Palacios

I found a friend who played something, not a sport but a musical instrument. He was not able to play in the music room because he was having difficulties learning the notes. I think this symbolizes perseverance, strength and practice. All of what he needs to become a better musician, and it's still a symbol of how we play.

— **Amanda Garcia**

A good band requires dedication and effort from all. You have to be focused and determined to practice alone for hours. It's the love of the music that propels you to do so. — **Ronnisha Dukes**

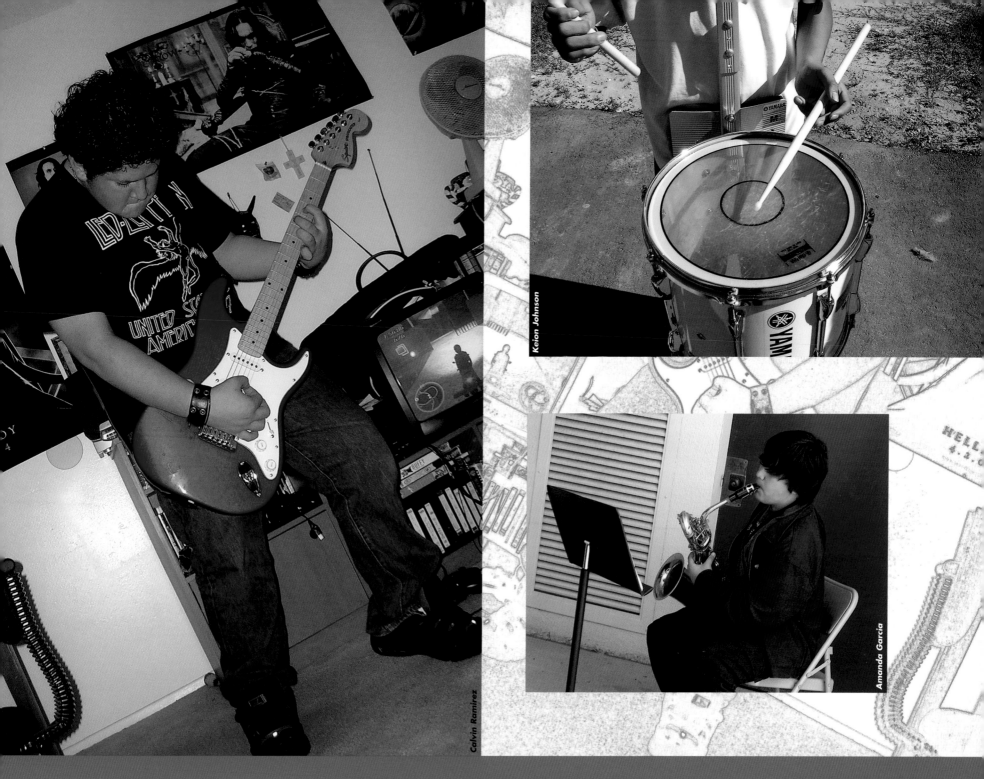

Calvin Ramirez

Keion Johnson

Amanda Garcia

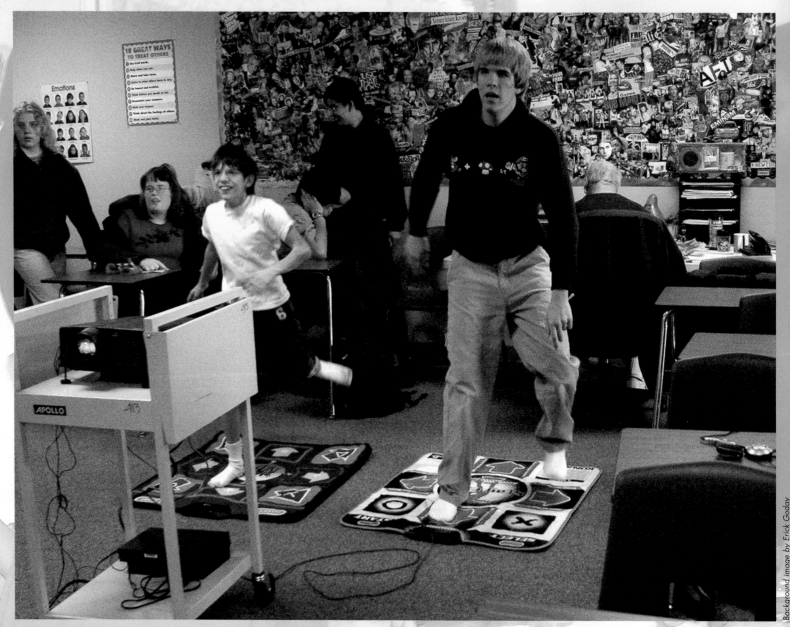

They have been working on it for awhile. Little by little they get closer and they know the end is near. The closer they get, the clearer the objective becomes and soon they will have everything in focus.

— *Amber M.*

This is a photo of me and my friend playing Dance Dance Revolution. One of my friends read in a newspaper that playing DDR will burn as many calories as running a mile. My PE teacher told him to write an essay and if it persuaded him then he would buy the game for the class. After my buddy wrote the essay, my teacher bought the game and this is what we play every Friday. My teacher puts the game on the LCD projector so the screen is enormous when we play. Some people call me the DDR master.
— **Dillon Chaffin**

Background image by Erick Goday

John "ollies" a nice seven-stair set to start the challenging game of SKATE. In this age, skateboarders spend the most time at school. They not only go to their local school, but also travel over 30 miles to skate a school made famous because of its stairs and hand rails.

— **Amir Pouyavand**

Alyssa Lopez

The majority of the guys at our school love playing basketball, but Juan's favorite sport is soccer. Juan is barely 15 years old, and he plays soccer like a professional. This is his passion and he plays as if the game depends only on him. Juan loves all sports but he especially knows many soccer tricks. He is a talented athlete even though he is not in a soccer league.

— *Maria Garcia*

Brandon East

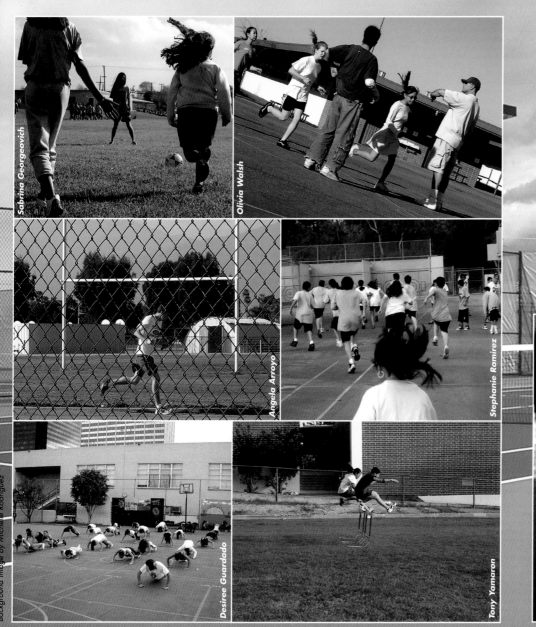

Sabrina Georgeovich

Olivia Walsh

Angela Arroyo

Stephanie Ramirez

Desiree Guardado

Tony Yamaron

Background image by Michelle Rodriguez

The skills I have acquired through sports help me in my everyday life. By competing in sports I have learned to be patient, and to be cooperative with others. I have learned that not everybody performs to their best ability every day. Everyone has off-days. I believe that if everyone were to compete in sports these skills would improve greatly, and it would cut back on the problems we have in the world today.

— Courtney Wivell

What kind of disgusting physical torture device is this? Perhaps a rope for flaling kids to death? What other horrors does this school hide?
— Daniel Woo

School can be hectic, and more often than not, boring! High schoolers need afterschool activities to help get through the school year. Excitement and relaxation are often critical to many high school students. Playing in the snow can fulfill both of these needs. Snowboarding is a great way to let off steam and aggression so that on Monday, everything is more peaceful. — **Kriss Dunning**

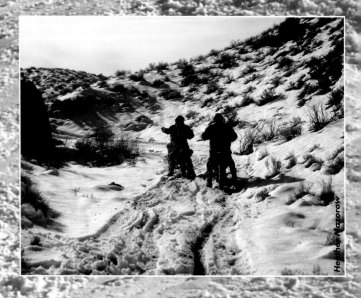

Smart and sleepy student by day, super snow-boarder by afternoon. Michael clears the small ramp with ease. — *Jonathan Yi*

Heather Mazorow

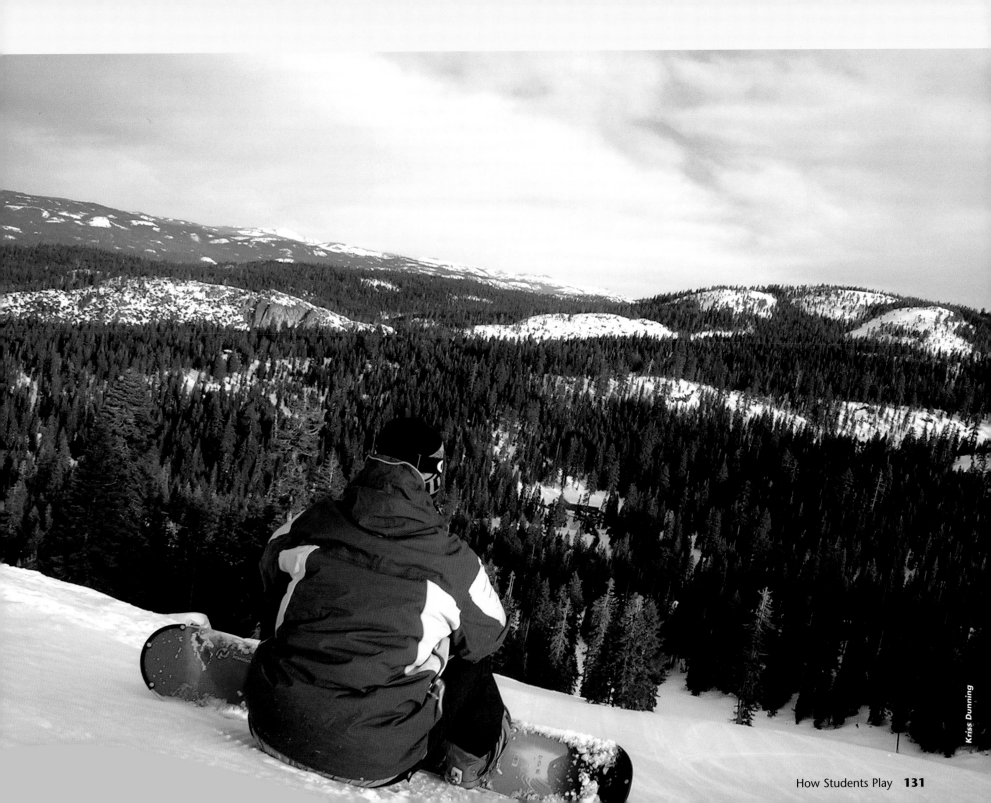

Kriss Dunning

Many times we even play with our food. When we get tired of the food given we use it for other things. But playing with the hamburgers is the best. We can use them as Frisbees, for throwing at each other, and even make something out of them. This is a work of "art."

— **Kevin Ramirez**

Brenda Ruiz

Priscilla Flores

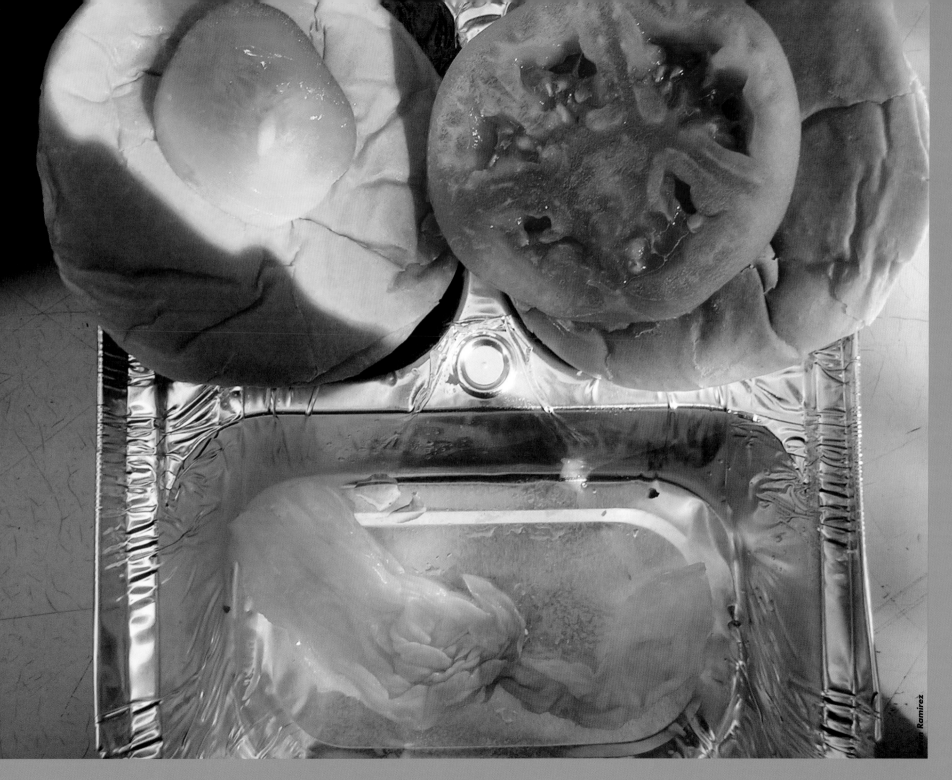

Ramirez

I can almost remember the days of my childhood when everything was much simpler. If it was a beautiful day, I could go outside and play. I could imagine that I was a princess having a picnic with my royal stuffed animals. I remember the joy that warmed me when I got new toys. Everyone would love me because I was so small. How I wish I could get back the days when I could enjoy my worry-free life.

— *Sherry Gong*

Maria Cisneros

Eddie Pineda

Jasmine Alvarez

Nick Belitz

Heather Mazorow

Kyle King

The rambunctious pair, Zaki Khorasanee and Noel Agtane play around and let off steam during break. They come out of their classrooms ready to jump around with energy. Spending one moment with Zaki and Noel makes you think they have caffeine running in their blood stream. Students like them run around our school every day, and it makes every day more exciting. They definitely bring a lot of spirit to our school. — **Emily Huynh**

Emily Huynh

Background image by Michelle N. Kim

Chelsea Wright

Soleil Garcia

Molly Draper

Yugioh! It's better than sports.

Zamuel Palomino

Violeta Papazyan

I think the fact that play time was created and put into the school curriculum is something that will never be forgotten. The fact that students have some time between classes to just unwind and talk to each other is an important thing.
— **Dro Amirian**

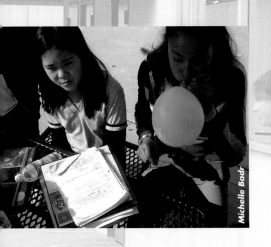

Michelle Badr

As you can see we're not kids anymore. We're standing on the threshold with one foot into adulthood and independence and the other one still holding on to our safe, sheltered childhood. There is a conflict in the age and the behavior that goes along with it, which brings me to my point of students, these days, making themselves look and seem older. A major one is girls and makeup. Shopping itself is fun, a girl can't have enough stuff, but shopping for makeup is something else. It is that place in time where girls try hard to appeal to the opposite sex and guys in return play with the fastest and most expensive of cars to look "cool". You could say that these are the toys of young adults and it is identified by both make-up and cars being used to enhance one's outer appearance for this is what teenagers only care about.
— **Ani Grigorian**

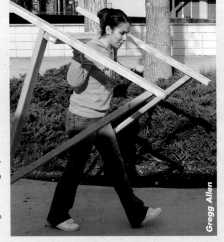

Background image by Brianne Hartshorn

Gregg Allen

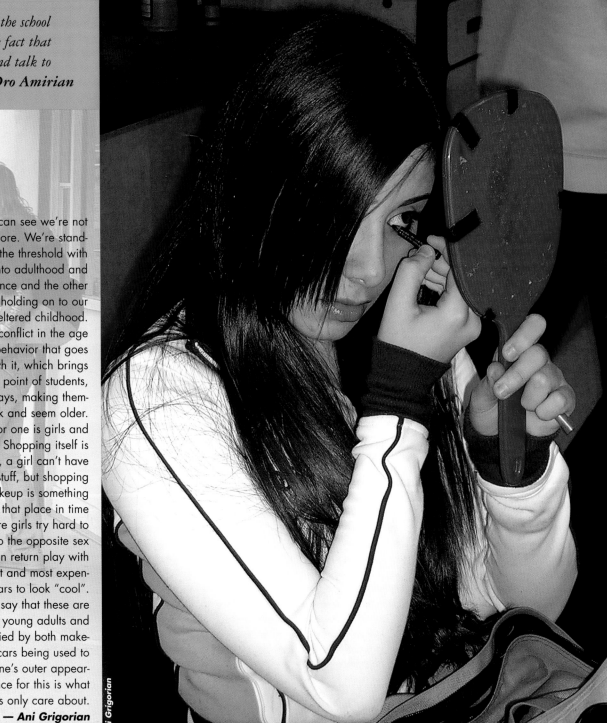

Ani Grigorian

Everybody has friends. Some have two or three, some have many. My friends are very important to me and they make the day go by easier. When friends join together they can make the simplest things great and always have fun in doing so. — *Megan Mckinsey*

the neighborhood: journey to and from school

Whenever someone asks where I live, I say, "in front of Maple Park," and usually the person's response is "Oh my…you must see a lot of action then." People don't really understand that living in front of Maple Park really isn't as bad as it sounds. Sure, there might be an occasional shooting or old grandpas fighting over a game of chess, but it sure is fun to watch it all happen from my porch. One day, when I was watering my grass, the SWAT team came jumping down my roof, dashing into the street to a taxicab. As police cars rushed to the scene, the driver of the taxi rolled on the ground with a gun in his hand pointing in the air. Right then I scrambled up the driveway, into my backyard, grabbed my dog, and ran in my house and locked the doors. After ten minutes, I looked out my window and saw the taxi driver in the police car, covered in blood, banging his head on the window while the police drove away. I grew up in a private secluded area on a hill and this was a new experience that I was not used to. But after a second shooting incident a few months later, I got used to the hustle and bustle of Maple Park.

Although Maple Park is quite an attraction during the day, at night it's just as peaceful as living on my old street. During the night, the park is a perfect place to walk and rethink your day or just sit on the porch and drink tea and relax. The park is beautiful at night and the calm lighting just puts you in the mood to sleep. During summer nights when the air is really hot and humid, my sister and I always walk together and talk about all our plans for the next year when school starts. We feel pretty

Jesse Tatulian

safe walking during the summer nights because there are many old people who walk with their friends or family… It's a moment when the community really seems to feel like one. My sister and I like to swing because this is the time when all the children are sleeping and the entire play area is ours. Sometimes we even see old couples swinging or trying to do the monkey bars. Once, during the hottest night, I remember seeing adults run through the sprinklers and just having a great time.

In rain or shine, people still enjoy the park, but the best time to just look at the park is during the rainy season. On rainy day mornings, I usually open all the shades that face the park and take in the lush vegetation blooming from all the rain. The tree branches that swing in the air almost look as if the trees are dancing to the thunder. Sometimes when it rains really hard, the

Background image by Da Zany Pitts

My sister, Christina Stewart, sometimes ignores the crosswalk near our house when she crosses the street, and so do I. A lot of other students who cross the street do, too. There usually aren't many cars driving by, so we feel safe crossing the street wherever we want. Most adults don't like it when we don't use the crosswalk, though, because it's not safe, so we use the crosswalk when there are adults around.

— *Jessica Stewart*

In the neighborhood outside the schools gates, among the manicured lawns and the picture-perfect white picket fences, there are the beliefs and prejudices that divide a town.
 —**Jae Park**

This picture communicates the fact that the neighborhood around our school is a well managed, nice place. Which perhaps says that our community cares about the way other people perceive us. No one wants to go to a school or be a part of a community that looks terrible or trashy. However, if a neighborhood is well-managed and properly taken care of, like ours, lots of people would love to live there and send their children to the local school.
 — **Antonia Idvita Melendez**

Kyle King

Ambar Lopez

Background image by Megan Lim

Heather Mazorow

field floods so I change the name to Lake Maple. It's pretty cool when you have a lake in front of your house for a week. Unfortunately, the city calls flood specialists to pump out the water. People don't usually walk at the park on rainy or windy days because the branches from the palm trees might fall and hit them, like they did to one unfortunate man five years ago. I remember that day like it was yesterday... I was walking in the park when this big gust of wind came and a branch broke off and hit an old man on the head. Fortunately, the man only had to get 80 stitches on his head and neck.

My house, which is across the street from the park, is probably one of the nicest houses on the block, although it wasn't when we bought it. I remember when I first came to the house, I was shocked to see a house without care. My house made the entire block look bad. After we cut the grass, the house had a totally new look. We had to call an architect to redesign our entire house and

change the landscape. I love living in this house more than my old house, and the area just adds to its character. Sometimes people think my house is a part of the park because of its landscape, and they come and sit on my lawn. Everyone knows my house because it has been the most drastically changed home in South Glendale and whoever had seen my house before the renovations knows the major reconstruction that we have done.

Although many people might view my area as an undesirable place to live, they have to look beyond how people abuse it. People won't see any live action drama on any TV channel or movie like the drama I see on my own porch. I wouldn't want to move from this place in a million years. My neighborhood has had such an impact on my life that it's hard to part from it during vacations. Just walking in the park is a vacation for me... a vacation from stress... a vacation from reality. — *Jesse Tatulian*

Angie Ruiz

Many crimes have been committed here, more than I can count. I find it no surprise when I come home and the cops are there. At night I see drug dealers, gun dealers, and shootouts. My neighbors are traumatized with everything that has happened. I am not traumatized as much because I am used to the neighborhood violence.

— **Eduardo Cuevas**

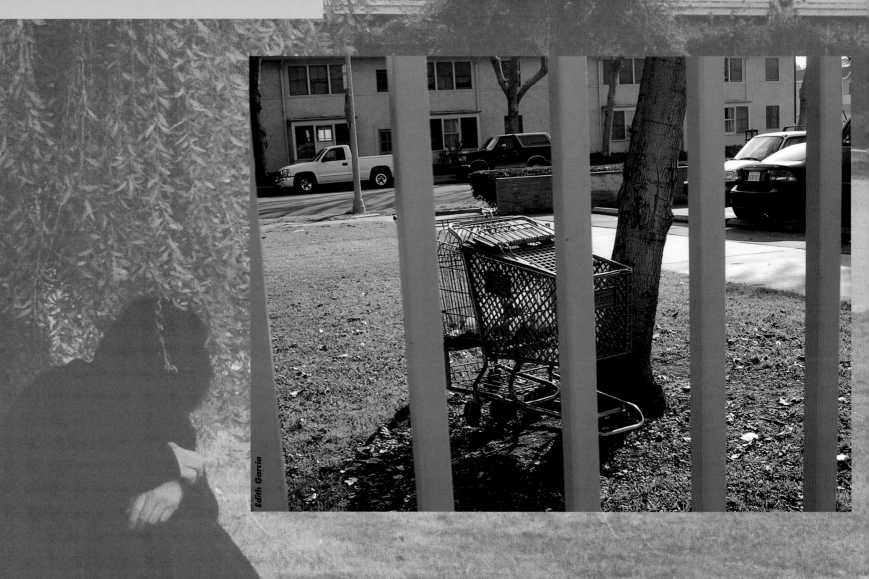

Edith Garcia

Background image by Sonia V.

ATWATER RANCH MARKET

Aleck Chan

Background image by Kariel Roberts

This is the bus stop across the street from our school. Kids have to take the city bus because there are no yellow buses for us.
— **Selina Davis**

This is my neighborhood. I hate looking at this every day. Sometimes I go to school in a bad mood after looking at all of the trash and graffiti.
— **Laikeya Patton**

Unfortunately, my neighborhood isn't the safest place to grow up for me and my two little brothers. Violence, gang members, and drug dealers are very common where I live. I want to leave my neighborhood for a quieter, peaceful place, with less pollution. All of the schools in my neighborhood are overcrowded, making it hard for students to learn.

— **Claudia Jeanette Torres**

This is a picture of the neighborhood that my sister and I have to go through in order to get to school. There are usually stray dogs in the area, but they don't hurt anybody. Sometimes along the way we meet up with some of our friends.

— **Cruz Ramirez**

Only through cooperation can we reach our desired result. The new "more-connected" society can use its knowledge to spread these blessings to the country, maybe the world. I will try to create this new thinking at my home. I only wish I could experience this kind of feeling when I go to school.
— **Albert Miranda**

Danielle Lemi

Joshua Vinueza

Brenda Ruiz

Jessica shines a big smile in the sunshine as she and her friend walk around the neighborhood. The neighborhood is a place where kids love to hang out.
— *Rocio Hernandez*

It is a place where I live and the place I leave everyday to go to school. My neighborhood is full of colorful houses, restaurants, and stores. It also represents my culture, community, and myself. — **Sally Ortiz**

The journey to and from school consists of open fields and barns, unlike big cities in which there are large skyscrapers and crowded residential areas. We are in a small town with many wide spaced areas like the one shown in this photo. This affects students for the better; the students aren't distracted by big busy areas next to the school so they can focus on their education.

Andrew Love

Kerry Gunsalus

The palm trees planted over 70 years ago delineated the borders of Corona, much like the rest of Southern California. They now serve as the sentinels over suburbia. — **Kate Boland**

I find it fascinating that our island can live and even thrive in a balance and harmony of being urban & rural. Some days in school I look around myself and feel extremely lucky to live in a place where we are surrounded, not by smog and the hustle and bustle of city life, but by one of the few places on Earth that is beautiful and will remain beautiful.
— *Spencer Creigh*

Daniel Koval

Melrose is in the Hollywood area. The Hollywood area is famous for the celebrities and its movies. However, it is dirty, loud, and crime-ridden. Yet for all that is going on, I believe that it is a very beautiful place to live in. This picture shows the two sides of the area. The dents in the sign represent the crime and the dreadful things that happen on the street and the palm trees represent the sunny and relaxed atmosphere of California. — *Eric Escobar*

All I could hear is the sound of the traffic and cars moving up and down the street. Whenever school comes to an end, and I get closer to my street and see my apartment building, it gives me a sense of relief because I feel at home. Neighborhoods give us an identity in the sense that it is the environment we live in and spend most of our time in, not to mention, "Home is Where the Heart Is". — **Zaruhi Galstian**

Luis Orenos

Brianna Cendejas

Stephen Leyva

I don't get to see my mom that much since she works very late from 7:00 in the morning to 7:30 at night. My mom has raised my sister and me alone and she's the only one that works to pay the bills. She doesn't have anyone to help her and that upsets me. But one thing is for sure, she is a strong woman. She has faced a lot of bad moments but she has gotten through it. I know I can change this situation by getting an education and going to a university. I want my mom to have a better life and not the one she has. I will keep helping her so one day she doesn't have to work so hard. — **Jessenia Banegas**

Silvia Gevorkyan

John Salazar

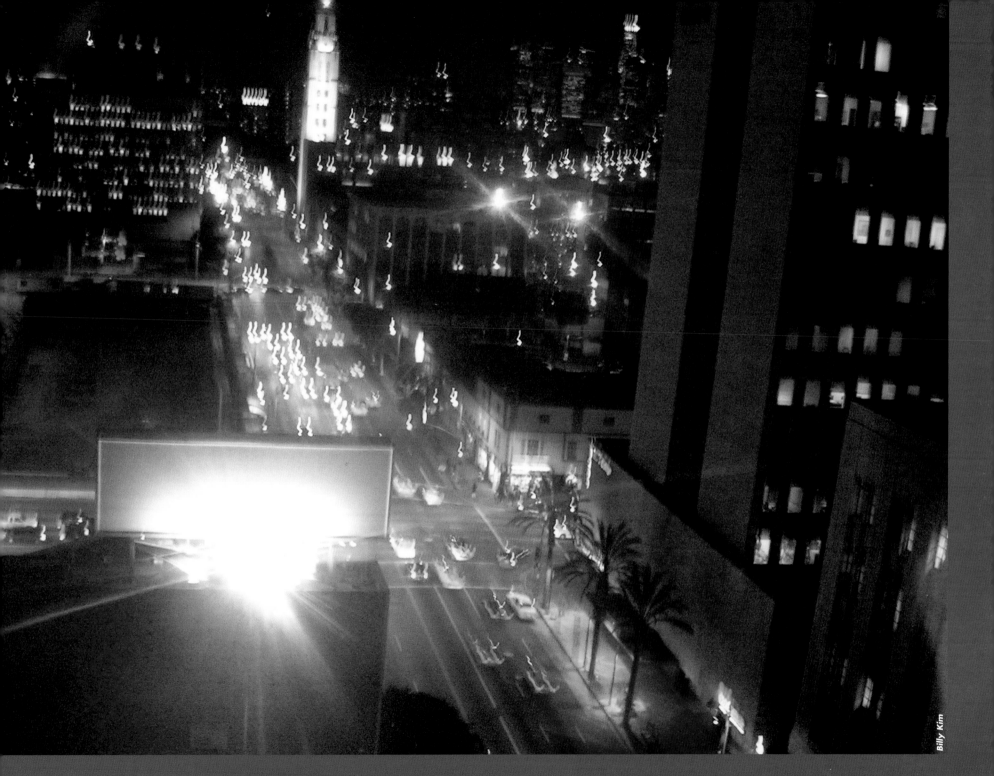

Billy Kim

My neighborhood is not the "borrow a cup of sugar" type; it is more like the "get off my lawn before I shoot" kind of neighborhood.
— **Elizabeth Dagit**

Ho Hyung Lee

Daniela Alvarez

Amanda Lankford

When I look outside the gates all that I see are oil fields. I feel like I am in prison when I am at school. We are isolated on the top of a mountain and if you tried to jump the fence there is a fifty-foot drop to the ground. The oil fields often leak horrible fumes towards our campus, causing major distractions in the classroom. — **Max Stockner**

Brendon Clemena

Max Stockner

The way to and from school is quite a journey for some students each and every day. Some students drive a junker car they bought themselves to school daily. Some students take the bus, which could be a ride as long as 5 to 95 minutes to and from school. Some students carpool with friends, or friends' parents to school. No matter how students make their way to school each morning, and back home each night, the trip is a good one with an awarding prize at the end of the line.

— *Kriss Dunning*

The bored bus driver waits for the day to end. I had never realized how boring it must be for a bus driver just driving loud, obnoxious kids to school and back home. I take the bus home every-day with all of my friends. **— Nakul Bhatnagar**

Kriss Dunning

Danica Lopez

SCHOOL BUS

34

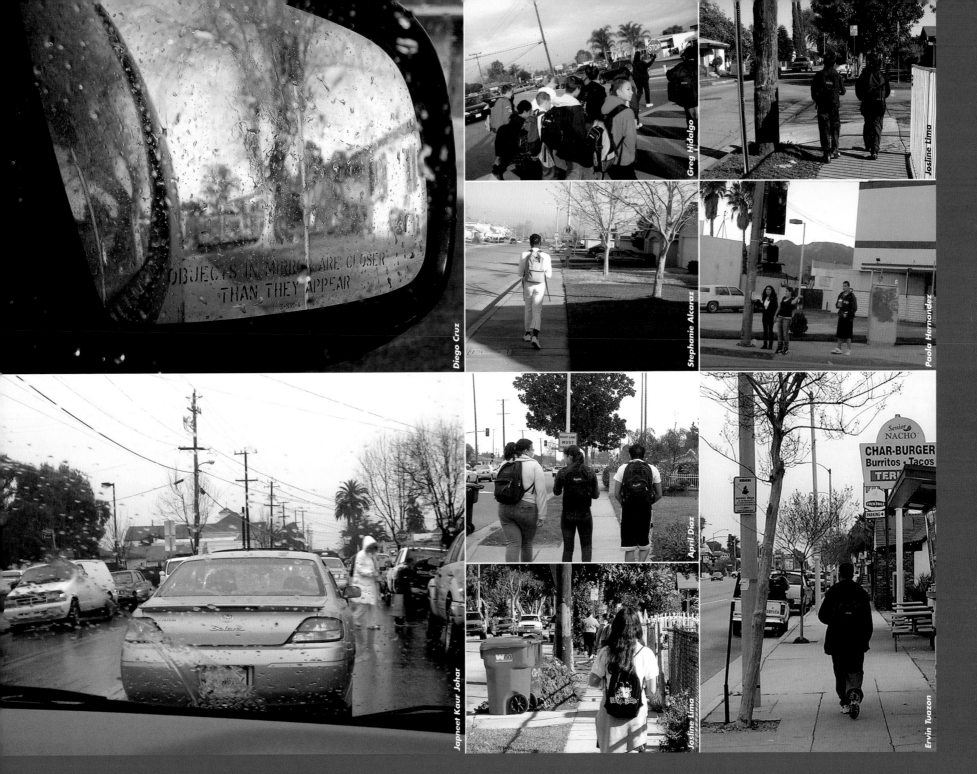

Diego Cruz

Greg Hidalgo

Josline Lima

Stephanie Alcaraz

Paola Hernandez

Japneet Kaur Johar

April Diaz

Josline Lima

Ervin Tuazon

Leaving a tract home in the suburbs and switching to a small urban apartment on the weekends can have a big impact on a teenager's life. Traveling between divorced parents means different neighborhoods, atmospheres, and people.
— *Anthony Gutierrez*

Cindy Lopez

Anthony Gutierrez

Cindy G.

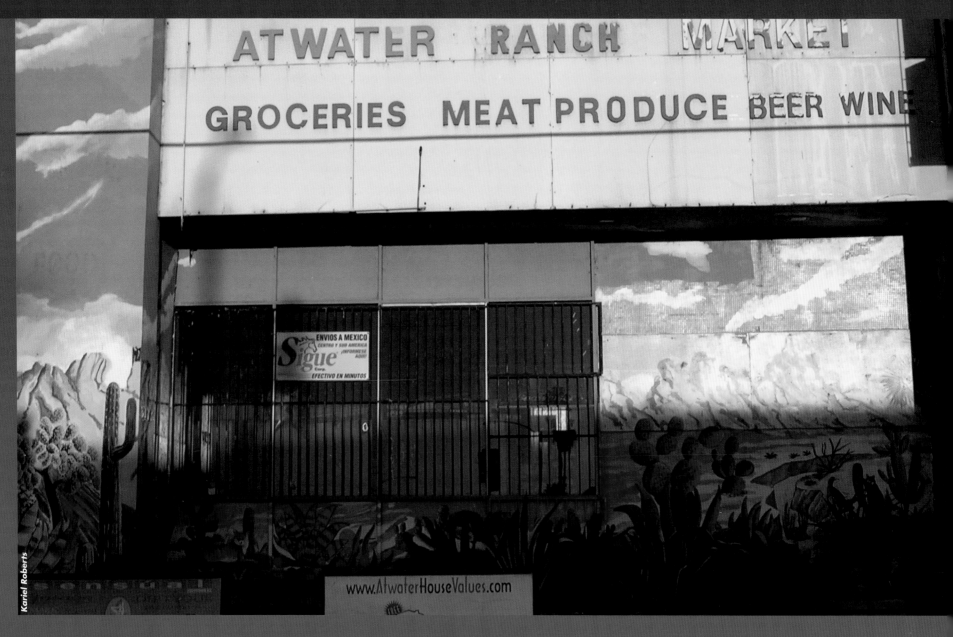

Kariel Roberts

Julie Kim

Na Hye Eunice Kim

Although our neighborhoods aren't always safe, it's good to come back knowing there's a couch waiting outside your door. — **Albert Miranda**

Taylor Hanssen

Dana Dowse

Kerry Gunsalus

Manuel L.

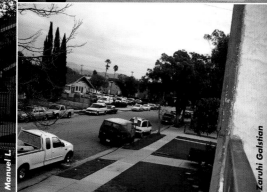
Zaruhi Galstian

Allen Villanueva

Michelle N. Kim

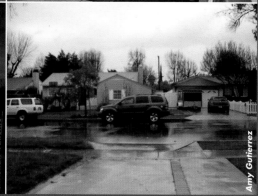
Christian Valiente

Amy Gutierrez

about the project organizers

COVINA·VALLEY
UNIFIED SCHOOL DISTRICT

For more than a century, Covina-Valley USD has served the communities of Covina, West Covina, Glendora, San Dimas and Irwindale. Covina-Valley schools provide the personalized service and caring culture of a small school district, where teachers and administrators know their »students by name.

Each year, our graduates earn in excess of $1 million in scholarships. Due to the high academic standing of Covina-Valley students, more than half of all graduates meet or exceed the admission requirements for the California State and University of California systems.

We provide a strong basic education underscoring reading, writing, language arts, math, science, social science and technology, which is aligned with the California Department of Education standards. Moreover, each campus offers leadership, curricular, and athletics/sports opportunities. A broad array of support services is available to children, adults and families.

An extensive arts program begins in elementary school, providing students with a well-rounded education. Our athletic teams garner California Interscholastic Federation (CIF) Championships, and are consistently ranked among the best in the region.

Each school enjoys high parent participation, active PTA and booster organizations. Community residents and local businesses serve as classroom volunteers, providing in-kind prizes to motivate and recognize student achievement, and to underwrite important school events.

The California Technology Assistance Project (CTAP) Region 11 is administered by Instructional Technology Outreach (ITO), a division of Technology Services at the Los Angeles County Office of Education. CTAP 11 works with Los Angeles County educators to integrate technology into teaching and learning. CTAP 11 designs and delivers professional development for teachers, administrators, and technical staff while supporting education technology programs, resource development, and the implementation of grants.

In addition to its partnership with CVUSD for the Emaze Solution project, CTAP 11 works with schools and districts on programs including AB75 principal training, CTAP 11 Mini-Grants for Teachers, Enhancing Education Through Technology (EETT) two-year leadership training, Instructional Technology Institute-Digital Media Workshop, Intel Teach to the Future, PALs (palmOne Academic Leaders) on integration of handheld computers, and a variety of other professional development sessions.

College of Education and Integrative Studies at California State Polytechnic University, Pomona offers two very distinct and unique programs: A Master's degree (MA) in Education with an emphasis in Educational Multimedia production and a Joint Doctorate degree (Ed.D.) in Educational Technology Leadership.

The Educational Multimedia Program is a production-based program that focuses on the creative integration of graphics, animation, video, DVD, audio and interactivity for educational and training settings based on the principles of instructional design. Students develop theoretical foundations in creative multimedia production, enhance their technical skills and become involved with creating a variety of innovative interactive multimedia projects for schools and corporate sector.

The Ed.D. Program in Educational Administration and Leadership is offered jointly by Cal Poly Pomona and the University of California, Irvine (UCI), along with three other partner CSU campuses: CSU Fullerton, CSU Long Beach, and CSU Los Angeles. The primary emphasis of the program at Cal Poly Pomona is on Educational Technology Leadership, with the aim of advancing the application of a broad range of technologies to achieving significant educational purposes.

about the sponsors

Given the right opportunities, we believe every student can develop a love of learning. We believe every teacher can stimulate young minds in ways that make a lasting difference. And we believe every school can raise achievement beyond what once seemed possible. Because we believe these things, Apple's mission is clear: It's our job to provide the very best tools for creating great opportunities. In Apple's 26 years of partnership with educators, we've never been more committed to that mission than we are today.

EPSON®

Epson America, Inc. is the U.S. affiliate of Japan-based Seiko Epson Corporation. The company develops and manufactures information-related equipment (computers and peripherals including projectors, printers, and scanners).

FIRSTCLASS®

FirstClass, a division of Open Text Corporation, provides software that enables corporate and educational organizations to effectively communicate, collaborate, share knowledge, and manage digital content.

Intelli-Tech is a value-added reseller of computer hardware and software. We have been providing corporate, government, and educational institutions with technology solutions since 1992.

about the sponsors

The men and women of Lifetouch share the vision to be the leading employee-owned photographic company providing innovative products and services that capture the spirit of today and preserve the memories of tomorrow.

Nikon, At the Heart of the Image™. Nikon Inc. is the world leader in digital imaging, precision optics and photo imaging technology and is globally recognized for setting new standards in product design and performance for its award-winning consumer and professional photographic equipment.

Enterprise Solution Group
Verizon Enterprise Solutions Group manages the design, operation and maintenance of end-to-end integrated network solutions for large business, government and education customers across the United States. With more than 7,800 employees in 35 states, Verizon Enterprise Solutions Group offers a complete range of basic and advanced communications products and services to meet the voice, video, data and IP-related requirements of its customers. In addition, over 5,200 field operations personnel support enterprise customers nationwide. In the enterprise market, Verizon Select Services Inc. provides Verizon long-distance service.

Verizon Foundation
Our philanthropic mission is to foster relationships and partnerships that address social and economic needs in America's diverse communities. We invest in and partner with organizations that focus on literacy and education initiatives, technology and work force development programs, and domestic violence solutions. And through Verizon Volunteers, we encourage our employees and our customers to make a difference by donating their time, money, and talents to nonprofit agencies—to help build stronger, sustainable communities.

acknowledgments

Project Organizers

Cynthia Agobian
Sierra Vista Middle School

Heidi Almberg
Traweek Middle School

Brian Anderson
CVUSD

Michele Biagioni
CTAP Region11

Ray Chavez
CTAP Region 11

Julie Drake
CTAP Region 11

Patti Fair
Apple Inc.

Jeffrey Goldman
Santa Monica Press

Sonia Hooks
CTAP Region 11

Dennis Jose
Northview High School

JoAnn Kilkeary
CVUSD

Jim Kuo
CTAP Region 11

Cheryl Lee
Apple Inc.

Joyce Lee
Cal State Fullerton

Shahnaz Lotfipour
Cal Poly Pomona

Sonica Patel, Student
Sierra Vista Middle School

Bob Pletka
CVUSD

Andrew Quintana, Student
Sierra Vista Middle School

Ashley Roxburgh, Student
Sierra Vista Middle School

Pam Rumph
Intelli-Tech

Lena Saleh, Student
Sierra Vista Middle School

Rosy Salgado
Intelli-Tech

PG Schrader
Cal Poly Pomona

Marty Silva
CVUSD

Christina Soderblom
Sierra Vista Middle School

Darin Sorrels
CVUSD

Kyle Svoboda
Traweek Middle School

Adam Wade
CTAP Region 11

Brenda Williams
CVUSD

Teacher Participants

Cindy Agobian
Sierra VIsta Middle School

Diane Atherton
Northview High School

Elizabeth Avery
Rosemont Middle School

Andrew Barnes
South Hills High School

Diane Bonilla Lether
Nimitz Middle School

Prem Bovie-Ware
Santiago High School

Joseph Brown
Covina High School

Courtney Bullock
Walter Reed Middle School

Judith Craemer
Clark Magnet High School

Debra J Dean
Phoenix Academy

Patrick Donahue
Bert Lynn Middle School

Jan Dyer
Jamestown Elementary School

Steven Edelman
Robert Fulton College
Prep School

Sylveser Edwards
Vasquez High School

Alicia Garbe
James Logan High School

Marlo Dorny
Cerritos High School

Patricia Guest
South High School

Fred Jaramillo
Golden Poppy

Robert Kaplinsky
Camino Nuevo
Charter Academy

Nichole Kessel
Sonora High School

Erin Kim
Camino Nuevo High Tech High

Bret and Kevin Lieberman
Golden Valley High School

Jon Mannion
LA High School

Connie Martin
T.S.King Magnet

Kathleen McGinley
Park School

JoAnn McKenna
Mulholland Middle School

William Moran
Avalon School

Linda Quinn
Whaley Middle School

Angela Rosario
Alvarado Middle School

Fabio Stephens
Las Palmas Middle School

Kyle Svoboda
Traweek Middle School

Jessica Tate
Northview High School

acknowledgments

Photographer Mentors

Michael Adams

Patrick Anderson
Anderson's Photography

Stephanie Baker
Stephanie Baker Photography

Keith & Tasha Cleveland
Beyond Images

Robert Crompton
Robert Crompton Photographer

Bruce Dale
Bruce Dale Photography

Chuck De Luca
Nikon, Inc.

Jill Enfield
Jill Enfield Photography

Jay Farbman

Amy Fink
Belliveau Photography

Kevin Fritz

Curtis Huettner

Anne Hutton
Anne Hutton Photography

Patrick Kelly
PH2OTOGRAPHY

Erin Kenly
Erin Kenly Photography

Barbara Kinney
Barbara Kinney Photography

Ed Kreiser

Laura Diane Luongo
Lauradiane Photography

Debbie Mangiafridda

Joe McNally

Alex & LeAnne Neumann
Alex Neumann Photography

Jim Paliungas, CPP
Palimor Studios

Yogi & Prem Patel

Deanna Quist

Leanne Reis
Photography by Leanne Reis

Jim Resler

Dan Roxburgh

Danny Swarts

Kathy Swatosh

Special Thanks

Vince Aniceto
Cartoon Network

Diane Atherton
Northview High School

Dr. Joan Bissell
Cal Poly Pomona

Kate Boland

Donna Branch

John Cerda

Jason Curtis

Selena Davis

Dr. Christina Dehler
Cal Poly Pomona

Lisa Digrado

Tim Garcia
CVUSD

Nicole Gerardi

Mark Hamill

Tamara Holder – (Mom)
Sierra Vista Middle School

Ed Humberstone
CVUSD

Koichi Ikeda

Kris Kemp
CVUSD

Joan Knespler
CVUSD

Jeanette Kwock

Eric Luke

Kim Marrero

Bob Meagher
CVUSD

Malissa Meeks
CVUSD

Jeremy Miller
CVUSD

Mike Miller
CVUSD

Gerald Morell
CVUSD

Ron Murrey
CVUSD

National Park Service

Ranger Craig Glassner
*Alcatraz Island Golden Gate
National Recreation Area
San Francisco, California*

Eileen O'Brien
Butterfield Elementary

Gayle Odell
CVUSD

Louis Pappas
CVUSD

Tracy Pedretti
Cal Poly Pomona

Beatriz Perez

David Peterson

Steve Smith
CVUSD

Jessica Tate
Northview High School

Claudia Torres

Shell Vacations – Club California
John M. Carter, *Regional
Director of Marketing*
Wendy Bolyard, *Regional
Compliance Officer*
San Francisco, California

Dave Williams
We Do Graphics

Jeff Wilson
Traweek Middle School

Pat Zickefoose
CVUSD

photo and text credits

Photo Credits

Acosta, Pamela p. 68
Akopyan, Ani p. 14, 106
Albro, Ty p. 72
Alcaraz, Stephanie p. 159
Allen, Gregg p. 23, 138
Almberg, Heidi p. 93
Alonzo, Daniel p. 46, 61, 90, 95
Alvarado, Oscar p. 61
Alvarez, Anthony p. 18
Alvarez, Daniela p. 43, 156
Alvarez, Jasmine p. 134
Amiragov, Ruben p. 30, 70
Amirian, Dro p. 50, 116
Anderson, Emma p. 53
Angers, Brian p. 54
Arellano, Adrian p. 17, 46
Armend, Corey p. 22
Arroyo, Angela p. 129
Badr, Michelle p. 138
Baek, Sara p. 51
Bal, Sandeep "Sunny" p. 56
Banegas, Jessenia p. 37, 95
Barahona, Carlos p. 70
Barillas, Rick p. 23
Barrera, Susana p. 70
Barron, Alina p. 52
Belitz, Nick p. 134
Benitez, Danica p. 46
Berg, Kassy p. 20
Bhatnagar, Nakul p. 29, 158
Boch, Christy p. 46
Boland, Kate p. 26, 49, 150
Bolson, Katie p. 69

Brown, Veronica p. 91
Campos, Anna p. 30
Caputo, Joseph p. 119
Carnes, Tiffany p. 92
Carrillo, Joshua p. 51
Castillo, Armando p. 128
Castillo, Vanessa p. 101
Cazares, Efren p. 111
Cendejas, Brianna p. 71, 153
Cerda, John p. 52
Chaffin, Dillon p. 43, 126
Chan, Aleck p. 145
Chavez, A. p. 96
Che, John p. 53, 108
Chin, Meagan p. 39
Cisneros, Maria p. 134
Clark, Elizabeth p. 15
Clarke, Ben p. 103
Clemena, Brendon p. 157
Cobb, Becky p. 29
Colopy, Michelle p. 23
Creigh, Spencer p. 151
Crosby, Hanna p. 18, 74
Cruz, Diego p. 58, 159
Dagit, Elizabeth p. 112
Davis, Selina p. 107, 145
DeLeon, Katy p. 61, 66, 105, 121
Diaz, April p. 45, 159
Dowse, Dana p. 161
Draper, Molly p. 104, 137
Dukes, Ronnisha p. 124
Dunning, Kriss p. 131, 158
East, Brandon p. 128
Escobar, Eric p. 10, 46, 90, 152

Esquivel, Jasmin p. 41
F., Hailey p. 84
Fairbanks, JJ p. 45, 72
Finger, Travis p. 52, 60
Fiske, Megan p. 89
Flores, Ana p. 43
Flores, Priscilla p. 132
Frontino, Elise p. 80
G., Cindy p. 160
Galstian, Zaruhi p. 110, 161
Garcia, Amanda p. 125
Garcia, Edith p. 58, 90, 144
Garcia, Manuel p. 30
Garcia, Maria p. 128
Garcia, Soleil p. 96, 137
Garcia, Victoria p. 43
Georgeovich, Sabrina p. 129
Gevorkyan, Silvia p. 154
Gill, Kevinjeet p. 11
Goday, Erick p. 126
Goodson, Billy p. 120
Graham, Chris p. 92
Grigorian, Ani p. 138
Guan, Janet p. 8
Guardado, Desiree p. 113, 129
Gunsalus, Kerry p. 150, 161
Gutierrez, Amanda p. 27
Gutierrez, Amy p. 161
Gutierrez, Anthony p. 160
Guzman, Luis p. 71
Gwendolyn, Kenny p. 82
Hanssen, Taylor p. 84, 161
Hartshorn, Brianne p. 29, 138

Hembree, Jodi p .69
Hendrickson, Kayla p. 29
Hernandez, Veronica p. 56
Hernandez, Alexandria p. 35
Hernandez, Crystal p. 14
Hernandez, Paola p. 159
Hernandez, Rocio p. 149
Hernandez, Savina p. 108
Hildalgo, Greg p. 159
Holder, Tori p. 49
Hu, Johanna p. 100
Hung, Wayne p. 33
Huynh, Emily p. 136
Inocelda, Francis p. 13
J., Michael p. 27, 109
Jacomb, Adam p. 100
Jimenez, Eddie p. 64, 108
Jimenez, Walter p. 22
Johar, Japneet Kaur p. 159
Johnson, Keion p. 125
Johnson, Sabrina p. 27
Johnson, Shameca p. 30
Juarez, Adrian p. 14
Kanjiya, Shrey p. 28
Kim, Billy p. 45, 155
Kim, Julie p. 161
Kim, Michelle p. 137, 161
Kim, Na Hye Eunice p. 91, 161
King, Kyle p. 38, 135, 143
Kofe, Namaia p. 24, 75
Koval, Daniel p. 55, 83, 151
Kovalsky, Ian p. 9, 116
La Com, Ryan p. 11
Laflin, James p. 121

Lankford, Amanda p. 156
Lee, Christy p. 108
Lee, Han p. 36
Lee, Ho Hyung p. 156
Lee, William p. 108
Lemi, Danielle p. 148
L., Manuel p. 161
Leong, Kerry p. 24, 45
Leung, Elle p. 93
Leyva, Stephen p. 47, 153
Lim, Megan p. 143
Lima, Jostine p. 159
Lopez, Alyssa p. 128
Lopez, Amber p. 143
Lopez, Angel p. 51
Lopez, Cindy p. 160
Lopez, Danica p. 65, 158
Lopez, Evarado p. 54, 111
Lopez, Silviano p. 52
Loska, Alex p. 81
Love, Andrew p. 150
Love, Corey p. 21, 101
Lucero, Raqul p. 63
M., Amber p. 33, 49, 85, 113-115, 120
Magdangal, Josh p. 45, 90
Marte, Bianca p. 114
Martinez, Daniela p. 34, 67
Martinez, George p. 64
Mason, Chris p. 98-99
Matus, Diana p. 77
Mazorow, Heather p. 130, 135, 143
McDonald, Victoria p. 72
McKelvey, Donovan p. 93
Mckinsey, Megan p. 139
Mejia, Christina p.17, 42

photo and text credits

Photo Credits

Melendez, Antonia p. 142
Meneses, Isidro p. 86
Meza, Elizabeth p. 101
Miller, Craig p. 67
Milz, Stephanie p. 84
Miranda, Albert p. 29, 161
Mok, Alison p. 29
Montano, Jose p. 12
Morones, Anabelle p. 8, 62
Mravic, Marco p. 27
Nguyen, Linda p. 119
Nieves, Karla p. 20
Novikova, Yekaterina p. 43, 77
Nudel, Stefy p. 67
Nuezca, Danielle p. 19
Nuila, Gloria p. 84
Octavo, Jose p. 62
Oliver, Candice p. 92
Oliver, Rebekah p. 78
Olivia, Ivan p. 36
Omar, Hamed p. 46
Orenos, Luis p. 45, 111-113,153
Ortiz, Javier p. 41
Palacios, Dalia p. 123
Palomino, Zamuel p. 137
Papazyan, Violeta p. 137
Park, Ashley p. 69
Park, Min Young p. 91
Patel, Henna p. 86
Patton, Laikeya p. 93, 118, 121, 146
Paz, Claudia p. 69
Perez, Fernando p. 94

Perez, Marisol p.71
Pineda, Eddie p. 134
Pitts, Da'Zany p. 140
Pouyavand, Amir p. 34, 56, 87, 127
Preciado, Noemy p. 41
Preston, Michael p. 98
Price, Jessica p. 92
R., Pedro p. 99, 114
R., Jesus p. 22, 48, 99, 122
Rainey, Shannon p. 16
Ramirez, Calvin p. 125
Ramirez, Cruz p. 147
Ramirez, Kevin p. 82, 133
Ramirez, Stephanie p. 64, 119, 129
Ramirez, Yvonne p. 13
Reyes, Tony p. 76
Rivera, Andy p. 57, 71
Rivera, Jessica p. 25
Roberts, Kariel p. 145, 160
Rodriguez, Cesar p. 17
Rodriguez, Michelle p. 129
Rosales, Carolina p. 67
Rouleau, Garret p. 102
Ruiz, Alejandra p. 119
Ruiz, Angie p. 13, 56, 143
Ruiz, Brenda p. 132, 148
Ruiz, Carlos p. 20, 70, 72
Rycewicz, Daria p. 98
Salazar, John p. 154
Saleh, Lena p. 119
Salmeron, Caroline p. 44
Samson, Michelle p. 102
Santoyo, Sally p. 100
Shneyder, Nika p. 102
Staggs, Dewey p. 122

Stepter, Nakira p. 32, 64
Stewart, Jessica p. 102, 141
Stockner, Max p. 157
Sugimoto, John p. 71
Talamayan, Roxanne p. 103
Tan, Alyssa p. 97
Tatulian, Jesse p. 140
Thai, Jaimie p. 74
Tomas, Pedro p. 20, 84
Torrez, Josh p. 74
Tran, Y-Lan "Laney" p. 68
Tuazon, Ervin p. 159
Urrutia, Kaitlyn p. 105
V., Sonia p. 144
Valencia, Araceli p. 27, 79
Valiente, Christian p. 161
Vasquez, George p. 88
Villanueva, Allen p. 161
Vinueza, Joshua p. 102, 148
Walsh, Olivia p. 129
Williams, Bianca p. 68
Williams, Dennis p. 11
Won, Joseph p. 59, 106
Woo, Daniel p. 129
Wright, Chelsea p. 137
Wu, Jason p. 31
Yamaron, Tony p. 129
Yang, Jacky p. 54
Yi, Jonathan p. 130
Zacarias, Leyla p. 69
Zhang, Annie p. 51, 117
Zhou, Gordon p. 121

Text Credits

Adams, Kelly p. 44, 54
Alaverdyan, Arpine p. 12
Amiragov, Ruben p. 33, 34, 56, 70, 90
Amirian, Dro p. 138
Banegas, Jessenia p. 154
Bellah, Caitlin p. 77, 78
Boland, Kate p. 38
Byramian, Christine p. 48
Carter, Robert p. 17, 58, 116
Castro, Karen p. 36
Cazares, Efren p. 110
Chin, Meagan p. 41
Clark, Elizabeth p. 16
Clayton, Zachary p. 84
Cuevas, Eduardo p. 144
Dagit, Elizabeth p. 156
Dunning, Kriss p. 130, 158
Galstian, Zarubi p. 153
Garcia, Amanda p. 124
Gong, Sherry p. 134
Gorton, Cate p. 30
Grigorian, Ani p. 62, 100
Gutierrez, Anthony p. 160
Henrique, Eric p. 74
Ho, Jackelynn p. 51
Huynh, Emily p. 136
Jorge, Adam p. 8
Kearney, Lindsey p. 22
Kim, Na Hye Eunice p. 64, 68
L., Manuel p. 112
Lara, Elizabeth p. 26
Lemi, Danielle p. 102

Long, Jessica p. 52
Love, Andrew p. 23
M., Amber p. 126
Magistrali, Margot p. 106
Mak, Ryan p. 80
Miranda, Albert p. 148
Mustin, Annemarie p. 24
Nguyen, Linda p. 121
Olivares, Lizeth p. 42
Ortiz, Sally p. 150
Park, Jae p. 108, 142
Patel, Sonica p. 82
Pelfrey, Katie p. 104
Perez, Fernando p. 95
Price, Jessica p. 92
R., Pedro p. 114
Ramirez, Kevin p. 132
Rivera, Andy p. 66, 86
Sanchez, Rogaciana p. 20
Sarkisyan, Serozh p. 72
Staggs, Dewey p. 122
Stockner, Max p. 157
Stonerook, Jeffrey p. 14
Tatulian, Jesse p. 140
Torres, Claudia Jeanette p. 147
V., Sonia p. 98
Venbuizen, Jennifer p. 18, 60
Weiss, Eddie p. 46
Williams, Dennis p. 11
Wivell, Courtney p. 129
Won, Joseph p. 28
Young, Kristina p. 96